THE COMPUTER REVOLUTION AND THE ARTS

T H E
Computer Revolution

UNIVERSITY OF SOUTH FLORIDA PRESS / TAMPA

A
N
D
the Arts edited by Richard L. Loveless

Watkins College
of Art & Design

The publication costs of this book were underwritten in part by a grant from the University of South Florida Research Council.

UNIVERSITY PRESSES OF FLORIDA is the central agency for scholarly publishing of the State of Florida's university system, producing books selected for publication by the faculty editorial committees of Florida's nine public universities: Florida A&M University (Tallahassee), Florida Atlantic University (Boca Raton), Florida International University (Miami), Florida State University (Tallahassee), University of Central Florida (Orlando), University of Florida (Gainesville), University of North Florida (Jacksonville), University of South Florida (Tampa), University of West Florida (Pensacola).

ORDERS for books published by all member presses should be addressed to University Presses of Florida, 15 NW 15th Street, Gainesville, FL 32603.

The Computer revolution and the arts / edited by Richard L. Loveless.
p. cm.
Based in part on presentations given at a conference
held at the University of South Florida, Mar. 1986.
ISBN 0–8130–0912–X (paper), 0–8130–0931–6 (cloth)
1. Computer art. 2. Art and technology. I. Loveless, Richard L.
N7433.8.C66 1989
702'.8'5—dc19
88-29357
CIP

This book is dedicated to my father, who devoted many hours of his life trying to understand what it was that I did, while bragging to everyone about being very proud of whatever it was.

C
O
N
T
E
N
T
S

ix Preface

1 Introduction

8 The New Renaissance: Art, Science, and the Universal Machine
 GENE YOUNGBLOOD

21 New Tools for Thought: Mind-Extending Technologies
 and Virtual Communities
 HOWARD RHEINGOLD

44 Computer Graphics and Artistic Ideas
 DUANE M. PALYKA

65 Thirty Years of Searching: Shifting Vantage Points
 SONIA LANDY SHERIDAN

76 The Cybernetic Dream of the Twenty-first Century
 MORRIS BERMAN

Preface

In March 1986 a conference entitled "The Computer Revolution and the Arts" convened at the University of South Florida in Tampa, to present the best ideas in current theory and practice about the role of the computer and its potential to change significantly the way we communicate in the next century and beyond.

The conference speakers, who represent some of the leading thinkers, writers, and practitioners in this field, were Gene Youngblood, Howard Rheingold, Rus Gant, Sonia Sheridan, and Duane Palyka. For the present volume, four of them have created essays that reflect their presentations at the symposium and the exchange of ideas that resulted, and discuss the implications of these ideas for the future. To complement the four essays developed around the conference theme, we invited Morris Berman, a noted science historian, to include his essay "The Cybernetic Dream of the Twenty-first Century." This historical and critical perspective of the emerging computer age seemed to lend an appropriate sense of balance to our love affair with the computer.

Acknowledgments

The symposium was organized and executed by Margaret Miller, director, University of South Florida Art Museum, and professor of art; Scott Bartlett, visiting professor, Visual Arts Department, University of South Florida; and myself. Support for the symposium came from the University of South Florida Suncoast Teacher Training Program, the College of Education, the Art Department, the University Film Association, the University Lecture Series, and the University Galleries through a grant from the Fine Arts Council of Florida, Division of Cultural Affairs and the National Endowment for the Arts.

Special thanks are extended to the following individuals: Dean William Katzenmyer, Associate Dean Edward Uprichard, and Associate Dean Marcia Mann, all of the U.S.F. College of Education; Alan Eaker, chairman of the Art

Department; Patrick Fanelli, Fine Arts Events coordinator; and Charlotte Rhae, who supplied her personal audiotapes of the proceedings to be used in organizing this book. Additional thanks go to Trident International Corporation, developers of the Thor-200, for providing this state-of-the-art projection system for the symposium presentations. We also thank the students who set up the telecommunication process with the Well and organized the media-tech participatory fair that concluded the conference.

We are grateful to Patricia Davidson for her organizational skills during the planning and staging of the conference and her enthusiastic assistance in the preparation of the manuscript.

I extend my personal thanks to my wife, Susan, for her spirited support as well as her editing skills, and to Sylvia Fiore and the University of South Florida Press Board and editorial staff for their generous support.

The orchestration of a conference like this one is made possible only through the commitment of people who are willing to take risks to stimulate inquiry that crosses the boundaries of interdisciplinary thought and practice. We are grateful to Gene Youngblood, Howard Rheingold, Sonia Sheridan, Duane Palyka, Rus Gant, and Morris Berman for providing a rich context for examining our relationship to the universal machine and the challenges of using this new tool for thought.

Richard L. Loveless

About the Authors

Gene Youngblood is a member of the faculty of the School of Film and Video at the California Institute of the Arts, and has also taught at the California Institute of Technology, Columbia University, the School of the Art Institute of Chicago, and the State University of New York, Buffalo. He has produced international conferences on the future of television for the Annenberg School of Communications at the University of Southern California and for the Directors' Guild of America.

He is the author of *Expanded Cinemas* (1970), the first book about video as an artistic medium, and is completing *Virtual Space: The Challenge to Create on the Same Scale as We Destroy,* the first of three volumes about the social, political, and artistic implications of the communications revolution.

Howard Rheingold is the author of *Tools for Thought: The History and Future of Mind-Extending Technology* (1985); *Excursions to the Far Side of Mind* (1988); *They Have a Word for It: A Lighthearted Lexicon of Untranslatable Words and Phrases* (1988); *Talking Technology,* with Howard Levine

(1982); *Higher Creativity,* with Willis Harmon (1984); and *The Cognitive Connection,* with Howard Levine (1987).

He has served as editor and writer for Bank of America, Xerox Corporation, Paramount Pictures Corporation, and Pacific Bell, and is presently a consultant to the U.S. Congress Office of Technology Assessments.

Duane M. Palyka is an artist, teacher, and computer scientist at the New York Institute of Technology Computer Graphics Laboratory. His computer art has been exhibited internationally since 1968, when it was shown in one of the first major exhibitions of such art, "Cybernetic Serendipity," at the Institute of Contemporary Art in London. His recent animated surrealistic production "Living above the Mouse's Ear" combines conventional animation and computer techniques. He is presently designing and implementing free-form sculpting tools as part of an in-house computer graphics three-dimensional modeling system.

Sonia Sheridan's artwork has been internationally exhibited and is in the collections of many major museums. From 1960 to 1980 she taught at the School of the Art Institute of Chicago, where she is now professor emerita. In the years since her retirement she has lectured and exhibited around the globe, most recently at the invitation of the Ministries of Culture of France and Spain. She has also been working with a computer graphics system developed by one of her graduate students, John Dunn, founder of Time Arts, Inc. Sheridan is a member of the Board of Directors of Time Arts and editorial advisor of the journal *Leonardo.*

Morris Berman has taught at Rutgers University, the University of San Francisco, Concordia University in Montreal, and the University of Victoria in British Columbia. He is the author of *Social Change and Scientific Organization* (1978), *The Reenchantment of the World* (1981), and *Coming to Our Senses* (1989). He has lectured widely in Europe and North America on the themes of cultural and scientific change in the history of the West. He resigned from university teaching in 1988 to devote himself to research and writing full-time.

Introduction

There are a few images from childhood that seem to linger in our consciousness, refusing to fade in the myriad of new life experiences that come our way. I can't remember how old I was or what grade I was in, but I will never forget a comment made by one of my elementary school teachers: "Richard, what you must recognize is that the sky never ends!" This declaration caused countless sleepless nights—not just for me, but for my classmate who lived next door. Long after our parents were asleep, we talked through our tin-can-and-string communication system that stretched from my attic to her bedroom window. How could it be that the sky never ends? If it never ends, how did it begin? It seemed far beyond our ability to comprehend.

Today, as I prepare to participate in a slow-scan video performance network event (in which artists and scientists from Boston, Nome, Alaska, and Tampa will create an electronic work and broadcast it live through the radio telescope at Haystack Observatory to extraterrestrial audiences), the teacher's comment still haunts my imagination: "Richard, what you must recognize is that the sky never ends!" I'm still trying to figure that one out; my tin can has been replaced by a few micro-chips that would be nearly invisible in the bottom of that old can. Little did we know how the world would collapse in scale through the new communications technology that was to develop, or how our perceptions would be altered and reshaped into a new form of global consciousness, one that continues to unfold in extraordinary ways.

For most of us growing up in the 1940s and 1950s, the arts and sciences were typically viewed as occupying distinct worlds, what C. P. Snow called "the two cultures." Sometimes similarities were observed: "Why do some artists and scientists specialize while others synthesize?" Connections between art and science were first proposed by J. H. van't Hoff in 1878. A poet and Nobel laureate in chemistry, van't Hoff studied some 200 biographies of notable individuals who had made significant scientific contributions before 1800. His conclusion was that most imaginative scientists are also artists, poets, musicians, or writers. Robert Root-Bernstein, a biochemist, continued

where van't Hoff left off, studying 150 biographies which he cites as proof that practice in the arts makes better scientists. Root-Bernstein says, "The ability to translate between modes may be the key."

I am not so interested in making claims about what makes either the artist or the scientist better, but in recognizing that their correlative talents form a viable context for addressing the future training of both. The ideas presented in this book are dedicated to those individuals, like myself, who have found themselves in the great parenthesis between the old and the newly developing myths about art, science, and the availability and capability of emerging technologies—myths that are destined to create countless sleepless nights for the child in each of us for some time to come.

The computer revolution touches each of us in mysterious ways. Edward Lias in his book *Future Mind* calls the computer the first gene switch in technology, because computers embrace all prior electronic media: they enhance, empower, and automate them, speed them up, recombine them, and output the results in any desired alternative medium. It is hard to imagine a future medium that will not somehow be tied to the computer.

The title of our symposium, "The Computer Revolution and the Arts," was intended to reflect a range of interests and concerns across several disciplines. In the essays that follow it becomes clear that defining the computer revolution may not be so much about subjects or modes of inquiry as it is about finding vehicles for both professionals and amateurs to communicate the nature of their passions to each other and to wider communities.

Gene Youngblood's essay, "The New Renaissance: Art, Science, and the Universal Machine," focuses our attention on two important issues of our time: technology and creativity. In describing the current crisis in consciousness, Youngblood calls for a resocialization process, one that distinguishes differences between the professional and the amateur. He describes the computer as a folk instrument capable of empowering a new renaissance of specialized communities. Characterizing this universal machine in Alan Kay's term, as a "metamedium," Youngblood shows us the origins of virtuality and the aura of simulacrum, threading his images through philosophical, historical, sociopolitical, and critical distinctions. His ability to reconstruct our consciousness by distilling such diverse yet related ideas provides a model for any of us who would respond to his call to participate actively in this resocialization process.

Youngblood rounds out his essay by explaining the conditions of electronic visualization and imaging concepts, and the potential role of interactive learning environments in redefining education. He concludes by defining some of the myths of the communications revolution and describing some of

the new forms that will be instrumental in creating "autonomous self-constituting reality communities":

> Combining the apparent objectivity of the photograph, the interpretive subjectivity of the painting, and the unrestricted motion of the hand-drawn animation, three-dimensional computer animation (or "digital scene simulation") may well be the most profound development in the history of symbolic discourse. It is possible to view the entire career not only of the visual arts but of human communication in general as leading to this Promethean instrument of representation. Its aesthetic and philosophical implications are staggering, and they are ultimately of profound consequence.

Howard Rheingold's essay, "New Tools for Thought: Mind-Extending Technologies and Virtual Communities," introduces us to the historical bases as well as the living, right-now, real-time autonomous communities that Youngblood describes as one of the new emerging forms of the communications revolution. Rheingold assuages our fears of mind-expanding technologies, challenging us to participate in defining the outcome of their empowerment: "The human mind is not going to be replaced by a machine, at least not in the foreseeable future, but there is little doubt that the worldwide availability of fantasy amplifiers, intellectual tool kits, and interactive electronic communities will change the way people think, learn, and communicate."

Rheingold begins his historical trip by reminding us that word processors, video games, educational software, and computer graphics were terms unknown to most people just ten years ago. Borrowing excerpts from his recent book *Tools for Thought,* he briefly traces the history of computation, contrasting the earliest co-creators of computer technology (the patriarchs and pioneers) with the latest breed, the "infonauts." Illuminating the earlier work of Babbage, Lovelace, Boole, von Neumann, and others, Rheingold brings us face to face with the realities of computer-linked communities. He concludes the first part of his essay with the ideas of Licklider and Taylor, who in the late 1960s predicted the profound social impact of computer-linked communities that might include as participants not only computer scientists and programmers but artists, engineers, housewives, schoolchildren, office workers, designers, librarians, and entertainers.

In the second half of his essay, Rheingold personalizes his journey into the subcultures of technology. Sharing his early fantasies about these changing realities and how they might affect his work, he challenges us to consider

the new options we have for living our ideas and ideals through a virtual community. He discusses time sharing and local area networks, the earlier forms that led to the BBS (bulletin board system), the most accessible information exchange base for the amateur as well as the professional. The BBS interactive communication process is compared to media that utilize face-to-face communications.

The essay concludes by introducing the reader to a virtual community named the Well (**W**hole **E**arth 'Lectronic **L**ink), of which Rheingold is a member. Describing his participation with over two hundred other people in the sharing and practicing of ideas through this medium, he communicates a sense of its transforming power. We are given a glimpse of what it might be like to join this aspect of the computer revolution.

During Rheingold's presentation at the conference, a Macintosh computer was used to access the Well, giving over three hundred audience members a chance to participate in an interactive dialogue with twelve Well members in different parts of the United States and Canada. With Rheingold at the keyboard, each of us was encouraged to respond to ideas and issues presented by contributors to the "electronic conference" in progress, and to present our own views. In structuring the content of our messages, we learned the mechanics of how virtual communities function, as well as the unique challenges that this new communication form presents.

Duane Palyka's essay, "Computer Graphics and Artistic Ideas," introduces us to the personal dilemmas and challenges that face the New Age artist. Palyka is a primary model for the new breed who characterize themselves as both artist and computer scientist. Wrestling with this dichotomy, he manages to bring the two worlds into a remarkably sane and productive balance.

Tracing childhood patterns that led him to a fascination with both his mathematical and his intuitive abilities, Palyka describes his attempts first as a student and later as a professional to satisfy his creative instincts. He is an experienced programmer, and his knowledge of the techniques and processes of the painting tradition affords a depth of understanding and insight seldom found in his scientific contemporaries. Using primary visual examples of both computer-generated and hand-painted works, he describes the technical aspects of paint programs, programming in C, and his most recent experiments with animation at the New York Institute of Technology. He concludes with a discussion of the ideal computer graphics tools, compared to what is now available.

In "Thirty Years of Searching: Shifting Vantage Points," Sonia Landy Sheridan shows how her computer images evolved from her traditional art

training, into a love affair with the new questions that act as a "figure" on a "ground" of emerging technologies. In her own words, "How did it happen that a woman six decades old is working with state-of-the-art technology and finds herself in worldwide demand?" Soon the reader understands why: "I saw that as we altered our perceptions of time and space, we altered our perceptions of objects in space, then of objects in time, until we arrived at a point where we were able to visualize the 'shape of time'." Taking us on a visual tour of four decades of work, Sheridan reveals multifaceted relationships with scientists, artists, technicians, and students. She connects the work completed in each decade with her recent *Wall Notes* and the images she currently creates on the Lumena system.

In 1957 Sheridan moved to Taiwan, and her ideas, grounded in Western art, were transformed by the new culture that bombarded her senses. The Asian influence produced a change in consciousness that was to fuel her process for the next ten years.

The sixties brought to fruition the changes that had incubated during her Eastern experience. Sheridan integrated the roles of scholar, artist, and teacher, proving that such personal integration is not only possible but necessary if one is to participate in the new revolution. The examples in this volume show the great variety of her arts, also reflected in her teaching processes in the Generative Systems program she created at the Art Institute of Chicago. It was an exciting time of many emerging technologies, when "for every 'dream' I painted, the new technologies validated the dream as merely another aspect of reality."

During the 1970s Sheridan found herself a focal point for the invention and testing of new tools for artists. Using Thermo-Fax and the 3-M Color in Color System, she created new courses in homography. She describes the effects of the electronic tools on her teaching and shows how the visual artist can use insights gained in the production of art to refine his or her teaching process. As we observe the contributions made by her former students to the unfolding story of newer media uses in art, her influence in contemporary art history becomes evident, as she continues to explore new uses of energy for art and to introduce colleagues and students to the challenges of developing computers for the artist.

The essays of Youngblood, Rheingold, Palyka, and Sheridan reflect their passion and optimism about the potential of the computer. A more critical view is propounded in Morris Berman's essay, "The Cybernetic Dream of the Twenty-first Century," which exhorts us to abandon the trendy forms that dominate some of our practices. He insists that we must make distinctions between varieties of holistic thinking if we are to create a new paradigm:

6 If we wish to avoid the pitfalls of the previous paradigm, we cannot afford to leave the insights of the magical tradition behind. By "magic" here I mean the affective, concrete, and sensual experience of life. This would be a paradigm grounded in the real behavior of people in the environment; one that would incorporate the sort of information that arises from our dream life, our bodies, and our relationship to plants, animals, and natural cycles. The alternative view—the belief that we can do without such things, that we can profitably regard reality as pure metaphor, "programming," or "patterned activity," that we can neutralize the pain and conflict of human life by what is in reality the latest technological fix—this is the cybernetic dream of the twenty-first century.

Buckminster Fuller advanced the notion that the roles of scientist and artist have both evolved out of the tradition of the craftsman. That is to say, they both look inside to identify new questions and new ways to see things that nobody else can; then they use design as a vehicle for clarifying those perceptions, seeking various form-finding processes to communicate that vision. It seems to me that this is a theory worth perpetuating, and that the key to practicing it is in the notion of "identifying new questions."

An artist friend, encountering a tropical storm for the first time, asked the question "Is there a tactile language in rainfall?" After twelve years of intense creative work and research, Steve Pevnick designed a computer-driven rainfall piece. The process was born out of the Fuller tradition of designer-craftsman. The resulting form is a fountain that releases water droplets in patterns that vary from double helix forms to poetry displayed in several languages. The sculpture is, in a sense, a three-dimensional animated rainfall. Rain is a symbol of transformation, of change, of cleansing—in all major religions of the world, a symbol of rebirth. Pevnick's idea that you can bring natural rainfall from "randomness" to the level of cultural imagery is a new form of wizardry. Yet, in his words, "What I hope for is that the ideas are intrinsically tied to my soul . . . that my process is not perceived as a particular fascination with technology."

Indeed, the contributions of Youngblood, Rheingold, Palyka, Sheridan, and Pevnick reflect a consciousness that should buoy Berman's spirits. In my view, they have *not* fallen prey to those cybernetic processes that are, in Berman's terms, "neutralized, formal, abstract, value-free, and disembodied." Each embraces a particular kind of "magic" that one might expect when the "correlative talents" of the interchangeable roles of artist and scientist are translated between modes of inquiry.

I have often referred to this era as the age of the Electronic Media Con-spiracy, suggesting that the challenge for each of us is to invent new myths and traditions about the role and training of the artist of the future. The Latin etymology of "conspiracy" translates as "to breathe together." What image could be more nourishing or more appropriate for our time: to define a natural, even magical, correspondence between technology and human needs and ideals.

Stephen Wilson, in the preface to his book *Using Computers to Create Art,* states, "I consider the conversion of the silicon sands of the earth into devices that can reckon, sense, and sing as one of the most significant po-etries of our times. There will be even more poetry if artists learn what they need to participate in more than superficial ways." I hope that this book will contribute in some way to the discovery of this new poetry.

The New Renaissance:

Art, Science, and the

Universal Machine

GENE YOUNGBLOOD

"We must create on the same scale as we destroy. The counterforce to the scale of destruction is the scale of communication."
Kit Galloway and Sherrie Rabinowitz

Industrial civilization faces a challenge that is unprecedented in human history: we must create on the same scale as we destroy. This challenge can be met only through instruments of simulation and conversation made possible by the computer. But those instruments will be of humanitarian value only insofar as their use is informed and guided by the discipline of art—that is, by the will to transformation.

Art is a process of exploration and inquiry. It asks: How can we be different? What is Other? What is our potential for aesthetic perception? Perhaps more than ever before, these questions are vital to the continued well-being of our civilization. But traditional forms of posing the questions and seeking their answers in the world of art are no longer adequate. We must explore the ways in which art might be revitalized through instruments appropriate to our circumstance.

This exploration must take place against a sociopolitical background of seemingly ungovernable crisis. The world's leading scientists in the relevant fields seem to be in agreement: we have created for ourselves a set of political and military crises, a set of technological and environmental crises, a

set of sociocultural crises, which may prove impossible to contain. The wisdom of our time is that these problems have been caused by the very institutions that were supposed to prevent them. They are symptoms of systemic dysfunction, crises of the very logic upon which industrial civilization is based—the logic of hierarchical authority and control known as heteronomy.

A Crisis of Imagination and Desire

We approach the millennium with a particular sense of our fallibility as a civilization, our mortality as a species, our responsibility as a generation and, alas, the inadequacy of our culturally limited imaginations in the face of prodigious challenge. For we are culturally and politically unprepared to face the perilous circumstances we have created. Crisis signifies danger and opportunity: it's a time for choice. But we perceive no alternatives. We find ourselves in a crisis of imagination and creativity, consciousness and desire. We seem incapable, as a nation, of imagining how to create on the same scale as we can destroy; and what can't be imagined doesn't exist.

In order to confront this crisis, we must resocialize ourselves. We must *create ourselves* as imaginative beings, as what Jacques Lacan called "desiring subjects" who accept or reject the world that we ourselves have constructed through our ability (or inability) to imagine and to desire—for we can't really desire that which we can't vividly imagine. It isn't true that contemporary attitudes and values actually have changed. What's true is that we're searching desperately to change them. We are restless with fresh and disturbing impulses, trying to rethink ourselves, realign ourselves, trying to live up to our troubled and inarticulate sense of new realities. We are trying to create a new culture that can make sense of, and give human proportion to, the technologies through which we now evolve and upon which our future depends.

Resocialization presupposes an ability to hold continuously before ourselves alternative models of possible realities, so that we might visualize and conceptualize other ways of being in the world. It implies not merely "consciousness raising" but the redefinition and reconstruction of consciousness. It is comparable to religious conversion, psychotherapy, or other life-changing experiences in which an individual literally "switches worlds" through a radical transformation of subjective identity. This requires continuous access to alternative social worlds—what sociologists call "plausibility structures" that serve as laboratories of transformation. Only in such autonomous "reality-communities" could we surround ourselves with

counter-definitions of reality and learn how to desire another way of life. We are talking about nothing less than cultural revolution, and for this we need a communications revolution—that mythical transformation of culture and consciousness which, for at least a generation, has seemed perpetually about to happen.

Professionals and Amateurs

The idea of a communications revolution used to be about video; today it's about the computer as a universal machine, a metamedium that will contain and become all media. It implies widespread access to tools for the simulation of audiovisual realities (computers) and to user-controlled networks for creative conversation about those simulations (two-way computer-video networks). In other words, a communications revolution would abolish the distinction between professional and amateur insofar as it is determined by the tools to which we have access as autonomous individuals. The hierarchical relation between producer and consumer would be eradicated through widespread access to tools for audiovisual production and to user-controlled networks of distribution and multimedia conversation. This in turn depends on the continued evolution of digital technology, which makes possible tools of ever higher quality at ever lower cost.

Surely no motivation is purer, no achievement more dignified than that of the amateur who does it for love. (The word "amateur" is derived from the Latin *amare,* "to love.") Yet in our professionalized society this most noble aspiration has been reduced to a sneering joke—the amateur as some kind of bozo—as though doing it for love were synonymous with ineptitude, an absence of quality and value. The amateur often isn't skilled enough to make money. But economic gain per se defines neither amateur nor professional. Certainly professionals can love their work and in this sense can also be amateurs—in which case the most important thing about them is their amateurism. Conversely, the amateur can be a professional, but in a different sense: one who is ethically or politically motivated, one who needs to communicate rather than simply to earn a living in communications.

The relevant distinctions between the professional and the amateur, then, have to do with commitment, values, and ethics. These are particularly vivid when differences in technical capability are erased: when both amateur and professional have access to the same tools of production, the only thing that distinguishes them is commitment. The professional is committed to profit or to institutional power (or both) rather than to the practice professionalized by

the institution, or the broader social and political context in which it is embedded. As a result, professionalism doesn't raise standards, it lowers them: professionals are frequently proficient, even "expert," at something they have no ethical insight into or concern about. But whereas the professional is an employee, the amateur is a constituent of a community; as such, his or her work is not a hobby or an avocation but a vocation—not in the industrial sense of a trade or profession but in the classical sense of a calling, as to a religious career or to the life of the artist or the revolutionary. Thus the practice of the amateur is inherently ethical: driven by moral vision, he or she judges actions in the light of their consequences. Love is not blind, it is visionary. That is why only as a nation of amateurs, not professionals, will we be able to resocialize ourselves and thus create on the same scale as we destroy.

The Computer as Folk Instrument

The nonstandard personal visions that drive the amateur often require the invention of new techniques or technologies: amateurism is synonymous with the tradition of user-built personal instruments, that is, folk instruments. To a greater extent than the professional, the artist-amateur makes a deep commitment to an instrument—building it, living with it and through it, plotting a life's course with it. This leads to technical virtuosity and constitutes a practice qualitatively different from that based on the time sharing of industrial tools for "productions" as special activities separate from life. The amateur's relation to tools is primarily ontological rather than commercial or even aesthetic: it's a kind of practical philosophy or personal discipline, a way of life, a way of being in the world and a way of creating a world to be in.

Most people now understand that the computer is a universal machine— so universal, in fact, that it has no meaning, no intrinsic nature, identity, or use value until we talk it into becoming something by programming it. As Alan Kay has pointed out, the computer can simulate many tools but it is not itself a tool. Computer tools are programs that transform the machine into "various kinds of levers and fulcra."[1] These programs are the folk instruments of our time. Through them, the user-built tool becomes the foundation of all the arts and sciences, for the tools that matter today are nonmaterial: they are the codes we write. It is the age of vernacular media: we polish our programs as water polishes a stone, as generations of men and women have polished a sentence. Now the fact of language as environment becomes vivid

and poignant in a new way; now the metaphor of "cultural codes" takes on constitutive and operational significance.

The New Renaissance

Whenever social modernization (technology) accommodates and empowers cultural modernization (desire and the imaginary) we call it renaissance. Today such conditions exist: the artist-amateur is empowered by a universal machine capable of containing and becoming all media, connected to user-controlled conversational networks that support autonomous reality-communities as laboratories of resocialization.

In many respects our present historical moment is not unlike that of the early Renaissance, which promoted an intellectual, pragmatic, and imaginative approach to the world that stimulated personal initiative and innovation. Similarly, the computer gives new importance in our time to personal resources like intelligence and imagination. The first Renaissance was a consequence of a communications revolution. The spread of literacy resulting from printing and lithography broke the medieval monopoly of the church over the information technology of the time, and this produced the Reformation. Today there is a second communications revolution: instruments of simulation (personal technology) and networks of conversation (social technology) are undermining the authority of the imperial broadcast and bringing forth a cultural revolution. Modern capitalism was born with the first Renaissance; in the knowledge economies of the new renaissance, capitalism will be radically transformed. Countries that took advantage of Renaissance technology became economically powerful, while those that failed to do so became socially and culturally impoverished. The same is true today. We face deep crisis if we fail to embrace the social, cultural, political, and economic imperatives of the new digital optoelectronic technologies.

The Universal Machine: Virtuality and Simulation

The computer is a medium that can dynamically simulate the details of any other medium, including media that can't exist physically. Alan Kay has called it "the first metamedium"[2]—it can and will contain and become all media. We witness today the first tentative gestures of the computer's universal reach: it is only beginning to contain and become words, writing,

printing, publishing; to contain and become sounds, speech, singing, music; to contain and become marks, designs, drawings, paintings, photographs, animation, movies; to contain and become heartbeats, automobiles, spaceships. This capacity of the universal machine to "become" many things while actually being none of them is known in computer jargon as "virtuality." The computer is a virtual instrument—a virtual typewriter, a virtual camera, a virtual piano, a virtual person, a virtual universe that contains, among other paradoxes, virtual computers.

Derived from the Latin *virtualis,* meaning "powerful capacity," the adjective "virtual" refers to phenomena that exist in effect or in essence but not in actual fact. The world in the mirror is the archetypal virtual space. Like three-dimensional objects in a computer simulation, a virtual space or virtual entity is a kind of phantom reality that is there but not there; it is real "for all practical purposes," yet it is not what it seems to be. For all practical purposes the image in the mirror is virtually myself, but it isn't really me.

A virtual instrument replaces things with rules-for-things. A mime simulates a broken arm by wearing a virtual cast, a cast made of rules; a scientific theory virtually reproduces natural phenomena by embodying their laws mathematically, allowing us to make accurate predictions "for practical purposes." The virtual entity, then, is a *simulacrum,* a product of simulation. Derived from the Latin *similare,* meaning "to imitate, feign, or represent," simulation characterizes what is most unique about the human species, the fundamental capacity that sets us apart from other animals. Whereas many animals employ a language of signs, only humans interact through symbols. We're the model builders, the storytellers, the picture makers—the simulators. If Descartes were alive today he would declare, "I simulate, therefore I am."

The Aura of the Simulacrum

The traditional tools of simulation in the arts are costumes, masks, scripts, cinematic and electronic effects. But when the computer is introduced, all instruments of simulation are collapsed into a single domain—that of the digitally encoded mathematical algorithms that make the computer a universal machine. This merging of the tools of art and science has tended to elevate simulation beyond technological problems into the domain of philosophical issues. The most intriguing has been the ontological question of decidability between the real and the unreal: a digitally processed photograph, for example, can no longer be regarded as evidence of anything

14 external to itself. Digital scene simulation has deprived photography of its representational authority just as photography disqualified painting in the nineteenth century; but this time the question of representation has been transcended altogether.

Of course representation was called to crisis decades earlier by literary semioticians in France. In the 1960s Jacques Derrida, following the pioneering work of Ferdinand de Saussure, argued that any given text can refer only to other texts, so that only the signifier remains, the signified, afferent world having been lost in the universal background noise of the "already written." In the 1970s Jean Baudrillard applied this critique to the world of audiovisual media.[3] A Neoplatonist, his approach is founded on the moral notion of authenticity: he laments the loss of the original, the authentic, and with them the possibility of Reality and Truth. Although he doesn't actually say so, it is clear that Baudrillard longs for the recovery of Walter Benjamin's "aura."

In "The Work of Art in the Age of Mechanical Reproduction," published in 1936,[4] Benjamin argued that historical artifacts of precious singularity (an ancient vase) and natural phenomena (a tree) possess for the witness an "aura" of authenticity that cannot be reproduced; that is to say, a transcendental quality that is lost in the act of reproduction ("it is meaningless to ask for the 'authentic' photographic print"). Benjamin defined the aura as "a quality of distance" that persists no matter how closely we may scrutinize the object that possesses it. This is nothing less than the religious concept of perfection. For Baudrillard, the aura of authenticity is lost forever in the world of media simulation, which he defines as the creation of a "hyperreal" that has no material origin or reality. In media culture, he argues, the ground of truth has been eradicated and all that remains is a self-referring galaxy of "simulacra of simulations" that renders decidability impossible. For Baudrillard it is a cultural and political cul-de-sac, the ultimate triumph of corporate capitalism. Instead of the territory preceding the map, he laments, it is now the map (media simulation) that engenders the territory (consumer culture).

Baudrillard's pessimistic critique leads only to a numbing powerlessness. But from a different point of view the same circumstances that he deplores represents hope: if we are to resocialize ourselves, if we are to construct a new culture in which to live, the map must necessarily precede the territory. Simulation is the prerequisite to transformation, mutation, secession. This calls for a new epistemology that would register the vital consequences of absence, countering a Western conceptual apparatus (and modernist aesthetic) grounded on presence. "We need," says Michel Foucault, "a philosophy of the phantasm."[5]

Such a view has recently been offered by yet another French philosopher, Gilles Deleuze. In a refreshing postmodern reading of Nietzsche,[6] Deleuze overturns Plato's (and Benjamin's and Baudrillard's) definition of simulacra as perverse deceptions, false images. For Deleuze, the simulacrum has an anarchistic function: it circumvents authority by including the spectator, the angle of the gaze, in order to produce the illusion at the point where the observer is located. The simulacrum should not be thought of as a degraded copy, Deleuze argues, but as an autonomous "force" with the positive power to subvert the world of representation; to transcend both original and copy, model and reproduction; to deny privileged points of view.

In the data space of a three-dimensional computer simulation (called "world space" or "world coordinate system"), there is no point of view. The digital simulacrum exists in this space as a kind of Platonic ideal, as pure generalized law without the specificity of particular being; it is brought into perceivable reality only when the observer specifies a point of view. In the translation from world space to screen space, reality is not reproduced, it is created: the ideal surfaces as pure simulation. Natural scientists are given a universe and seek to discover its laws; computer scientists *make* laws and the computer brings a new universe to life.[7] We gaze in fascination upon these digital simulacra: they possess an "aura" precisely because they are simulacra, vivid chimera of a new kind of eidetic vision. They refer to nothing outside themselves except the pure, "ideal" laws of nature they embody. They have that "quality of distance" no matter how many degrees of manipulative freedom we have over them, because they exist in the dematerialized territory of virtual space. They are the definition of freedom in the digital age.

Ours is a time in which ontological questions of truth and falsehood are less relevant than issues of control—control of meaning, control of context. Only a tradition bound to the precious object as commodity would find problematic the replacement of "reality" by "simulacra of simulations." For those who conspire in electronic visualization the issue is not a return to some "authentic" reality but the power to control the context of simulation. The fear of "losing touch with reality," of living in an artificial domain that is somehow "unnatural," is for us simply not an issue, and we have long since elected to live accordingly. What matters is the technical ability to generate simulations and the political power to control the context of their presentation. Moralistic critics of the simulacrum accuse us of living in a dream world. We respond with Montaigne that to abandon life for a dream is to price it exactly at its worth. And anyway, when life is a dream there's no need for sleeping.

Combining the apparent objectivity of the photograph, the interpretive subjectivity of the painting, and the unrestricted motion of hand-drawn animation, three-dimensional computer animation (or "digital scene simulation") may well be the most profound development in the history of symbolic discourse. It is possible to view the entire career not only of the visual arts but of human communication in general as leading to this Promethean instrument of representation. Its aesthetic and philosophical implications are staggering, and they are ultimately of profound political consequence.

If photography is making marks with light, then computer imaging is a kind of photography, but one in which the "camera" is only a point in virtual space and the "lens" is not a physical object but a mathematical algorithm that describes the geometry of the image it creates. In a way that is haunting and prophetic, the most advanced form of photography now imaginable returns us to the Renaissance concept of perspective as a geometric rather than an optical phenomenon and situates reality once again in a domain of mathematical constructs.

The most important consequence of this was suggested in 1974 by the Belgian philosopher Vilem Flusser, even though he was thinking only about video, not computers. Flusser observed that video serves simultaneously the human capacity for imagination (visualization) and for conceptual thinking. It is an imaginative tool, he said, because its messages appear as images on a screen; conceptual because the images flow like texts, unfolding a narrative. Thus video allows us both to imagine events and to conceive them. Flusser suggested, however, that if it were "used properly" video might permit us not only to conceive images but also to *imagine concepts.* "Written texts allow us to conceive images," he pointed out, "but no medium yet exists for the imagination of concepts. Sketches of molecular structures are examples of failure in this domain."[8]

Of course Flusser was doubly wrong: it is the computer, not video, through which we can "perceive concepts and thus imagine them"; and we possessed such a tool even as he spoke—the display algorithm, which merges two modes of description, numerical (conceptual) and visual (perceptual), that previously occupied mutually exclusive phenomenological domains. Through the display algorithm, numerical description can account for all the properties of an image: it can construct, and be reconstructed from, the visual. An innovation of degree—the degree of complexity that is possible through mathematical description—becomes an innovation of kind—the nonmaterial nature of the virtual entity, the digital simulacrum,

whose visualizations are essential if we are to create on the same scale as we destroy.

Through the integrative power of the universal machine the artist-amateur commands a medium that is simultaneously spoken word and written sign, aural and visual image, in color or black and white, still or in dynamic motion—all in virtual space and therefore subject to none of the restrictions of physics and gravity that govern the material world. But even more important is the ability to *interact* dynamically with these expressions, to change them and to be changed by them in the process, for transformation is proportional to the bandwidth and frequency of the feedback loop.

Interactivity

Resocialization is a form of education. But it can't be taught. It's not something you *acquire*, it's something you *do.* There is a crucial difference between teaching—which implies a fluidic theory in which liters of knowledge-substance are somehow poured from a teacher vessel into a student vessel—and the notion of learning, which implies some process going on in the learner. As they say, you can lead a child to Euclid but you can't make him think. In the Piagetian sense a child is an autonomous builder of mind rather than a recipient of "education" as commodity. Derived from the Latin *educere,* to educate means to educe, to pull out, not to push in: the learner must be invited out. This can happen only through interaction. Learning happens when attention is focused; and, as arcade games demonstrate, interactivity is the best way to focus attention.

To know the world, said Pavell, we must construct it. We must construct it not once but three times: with our muscles, with our vision, and with symbols that transcend immediate reality. These are Piaget's stages of learning; they're active simultaneously, with one of them dominant at a given stage of growth. First physical activity dominates, then visual relationships, and finally we learn to deal with life symbolically: we enter the domain of simulacra. This is why computer technology is essential for resocialization: only through computers can media become interactive, and only through interactive media can we construct—that is, simulate—the worlds we wish to know.

In interactive media, just as with books, there's an audience of one; but the difference is that the passive reader now becomes active *player* as conversation replaces monologue. To use cinematic metaphors, viewing ratio replaces shooting ratio and the idea of production value is reversed: the

player is the product. *You* are the developmental project that evolves. The computer is a tool you retool to work on yourself. The issue is interaction not with machines but with people mediated through machines: it's interaction with intelligence, with mind. In interactive art, *response itself is the medium,* not the audiovisual interface through which the response is manifest.

What is interactivity? Is it a menu of multiple choices in a branching structure? Or is it something less controlled by the author, where the environment changes as a result of the user's interactions with it, so that possibilities are generated that the author didn't think of? The latter is creative conversation, a higher level of interactivity—a generative rather than merely reactive process. To me it is the true computer art, the only art form unique to the computer. The technology for it doesn't yet exist; it requires artificial intelligence, which won't be sufficiently evolved for some years yet.

Meanwhile, interactive video will be the new gallery video, the new electronic art form for museums. Artists are beginning to explore the medium, and some interesting strategies are being developed. By far the most interesting to date is Grahame Weinbren's *Erl King,* which explores the possibilities of subtexts simultaneously available with the unfolding of a primary narrative, so the narrative can be modified or expanded by the player. Bill Viola has spoken of shooting scenes from, as it were, a spherical point of view—providing many different viewpoints on the events and then allowing the player to assemble different movies from different combinations of these viewpoints. Myron Krueger constructs environments with visual interfaces that change and respond to the physical movements of participants in the space.[9] When interactive strategies are amplified through two-way audiovisual telecommunications, the foundation for resocialization will be in place. The telecommunications projects of Kit Galloway and Sherrie Rabinowitz (*Hole in Space,* 1980, and *Electronic Cafe,* 1984) are the best examples of revolutionary communication networks designed by artists.

Networking: The Myth of the Communications Revolution

Most of us think of the computer as an information-processing machine. But in fact it's the most powerful *communication* device ever invented. Everything the computer does can be understood as enabling or enhancing some process of communication. Computer networking has become synonymous with the communications revolution that is gradually decentralizing our hierarchical mass culture into a republic of highly specialized autonomous networks (a heterarchy).

A communications revolution isn't about technology; it's about possible relations among people. It implies an inversion of dominant social relations through structural inversion of the mass media: today's vertical order would become horizontal, hierarchy would become heterarchy, centralized output would be balanced by decentralized input, mass communication would yield to creative conversation, commerce would be subservient to community, and the nation-as-audience would disperse into a republic of autonomous, self-constituting "reality-communities"—social groups of politically significant magnitude, realized as communities through telecommunication networks and defined, therefore, not by geography but by consciousness, ideology, and desire.

In other words, as a network becomes more specialized the concept of audience becomes that of constituency and the distinction between producer and consumer becomes increasingly meaningless. The professional as hired expert in the techniques of producing commodities called "programs" for mass distribution to "consumers" is replaced by the more appropriate model of the skilled amateur as constituent of a community of desire.

Today the notion of networking means that I type at you and you type at me and these typed-out texts appear on our screens. But this is only the beginning of computer-based communication. The Macintosh already has a visual interface for networking. The next step will be to add crude animations with spoken and printed text, then to make the animations less crude, more real-time, more dimensional and rendered, the voice more human. Meanwhile there's that other world, video, which is rapidly becoming digital. There's no difference between digital code that comes out of a computer and code that comes out of a camera. They will eventually merge (as they already have in digital video effects devices), and the result will be the engine that will drive the communications revolution.

As a result, the postindustrial concept of networking will gradually replace the industrial concept of distribution. But this time we're starting out with a very different structural background—the switched telephone system versus the imperial broadcast. Computer networking already has the revolutionary characteristics that are the myth of the communications revolution. It's decentralized, personalized, completely conversational. The computer itself is conversational and the network to which it has historically been attached is conversational.

There's one little problem: the phone system can't yet handle real-time video, that is, cinema. That waits for fiber optics, which is profoundly political because it means that the bandwidth going into the home would finally be equaled by the bandwidth coming out of the home. The popular press treats

20 these issues as though they were separate from movies and video art. But they're not. Electronic cinema will be superimposed over networking as we know it today, creating the foundation for the rise of autonomous reality-communities. As constituents of these communities we could produce models of possible realities (art) and also control the cultural contexts in which those models are published and perceived (politics). I believe this is not only possible but essential for human dignity and survival: the continuous simulation of alternative realities within autonomous reality-communities constitutes a new renaissance in which the artist-amateur might effectively address the profound social and political challenges of our time.

Notes

1. Alan Kay, "Learning Versus Teaching With Educational Technologies," *Educom Bulletin* (Fall–Winter 1983): 17.

2. Alan Kay, "Computer Software," *Scientific American* 251, no. 3 (September 1984): 54.

3. Jean Baudrillard, *Simulations,* trans. Paul Foss, Paul Patton, and Philip Beitchman (New York: Semiotext(e), 1983).

4. Walter Benjamin, "The Work of Art in the Age of Mechanical Reproduction," in *Illuminations,* trans. Harry Zohn (New York: Schocken Books, 1969), 217–51.

5. Michel Foucault, "Theatrum Philosophicum," in *Language, Counter-Memory, Practice,* ed. Donald F. Bouchard (Ithaca, N.Y.: Cornell University Press, 1977), 165–96.

6. Gilles Deleuze, "Plato and the Simulacrum," *October 27* (Winter 1983): 47–56.

7. Kay, "Computer Software," 55.

8. Vilem Flusser, "Two Approaches to the Phenomenon, Television," in *The New Television,* ed. Douglas Davis and Allison Simmons (Cambridge, Mass.: M.I.T. Press, 1977), 234–47.

9. Myron Krueger, *Artificial Reality* (Reading, Mass.: Addison-Wesley Publishing Company, 1983).

New Tools for Thought:

Mind-Extending Technologies

and Virtual Communities

HOWARD RHEINGOLD

The History and Future of Mind-Extending Technology

South of San Francisco and north of Silicon Valley, near the place where the pines on the horizon give way to live oaks and radio telescopes, an unlikely subculture has been creating a new medium for human thought. When the mass-production models of present prototypes reach our homes, offices, and schools, our lives are going to change dramatically.

Over the past three years, I have observed these cognitive technologists at work, tested their prototypes, become acquainted with the quest that unites a diverse coalition of interests, and slowly found myself becoming part of this rd & f ("research, development, and fun") community that is using today's experimental mind-extending tools to build tomorrow's versions—the ones everybody will be able to use. My observations of the subculture of mind-extending technologists resulted in a book, *Tools for Thought,*[1] that set the mind-extension revolution within the larger context of the history of computation and the history of personal computing. Part of my purpose in this essay is to provide a glimpse of this historical context. The other part of my purpose is to introduce you to a living, right-now, real-time virtual community.

The first of these mind-amplifying machines will be descendants of the devices now known as personal computers, but they will resemble today's information-processing technology no more than television resembles a fifteenth-century printing press. They aren't available yet, outside the research institutions that invented them, but they will be here soon. Before

21

today's first-graders graduate from high school, hundreds of millions of people around the world will join together to create new kinds of human communities, making use of a tool that a small number of thinkers and tinkerers dreamed into being over the course of the past century.

Nobody knows whether this will turn out to be the best or the worst thing the human race has done to itself, because the outcome will depend in large part on how we react to it and what we choose to do with it. The human mind is not going to be replaced by a machine, at least not in the foreseeable future, but there is little doubt that the worldwide availability of fantasy amplifiers, intellectual tool kits, and interactive electronic communities will change the way people think, learn, and communicate.

It looks as if this latest technology-triggered transformation of society could have an even more intense impact than the last time human thought was augmented, five hundred years ago, when the Western world learned to read. Less than a century after the invention of movable type, the literate community in Europe had grown from a privileged minority to a substantial portion of the population. People's lives changed radically and rapidly, not because of the printing press itself, but because of what that invention made it possible for them to know. Books were just the vehicles by which ideas escaped from the private libraries of the elite and circulated among the population.

The true value of books emerged from the community they engendered, an intellectual community that is still alive all over the world. The printed page has been the medium for the propagation of ideas about chemistry and poetry, evolution and revolution, democracy and psychology, technology and industry, and many other notions far beyond the ken of the people who invented movable type and started cranking out Bibles.

Because mass production of sophisticated electronic systems can lag ten years or more behind the state of the art in research prototypes, the first effects of the astonishing achievements in computer science since 1960 have only recently begun to enter our lives. Word processors, video games, educational software, and computer graphics were unknown to most people only ten years ago, but today they are billion-dollar industries. And experts agree that the most startling developments are yet to come.

A few of the pioneers of personal computing who still work in the computer industry can remember the birth of the dream, when the notion of personal computing was an obscure heresy in the ranks of the programming priesthood. Thirty years ago, the overwhelming majority of the people who designed, manufactured, programmed, and used computers subscribed to a single idea about the proper (and possible) place of computers in society:

"Computers are mysterious devices meant to be used for mathematical calculations." Period. Computer technology was believed to be too fragile, valuable, and complicated for nonspecialists.

In 1950, you could count the people who took exception to this dogma on the fingers of one hand. The dissenting point of view shared by those few people involved in a different way of thinking about how computers might be used—to enhance the most creative aspects of human intelligence, for everybody, not just the technocognoscenti. Those who questioned the dogma suspected that if the computer could be made more interactive, it might help us to speculate, build and study models, choose between alternatives, and search for meaningful patterns in collections of information. And they wondered whether this newborn device might become a communication medium as well as a calculating machine.

These heretical computer theorists proposed that if human knowledge is indeed power, then a device that could help us transform information into knowledge would be the basis for a very powerful technology. While most scientists and engineers remained in awe of giant adding machines, this minority insisted on thinking about how computers might be used to assist the operation of human minds in nonmathematical ways.

Tools for Thought focuses on the ideas of a few of the people who have been instrumental in creating yesterday's, today's, and tomorrow's human-computer technology. Several key figures in the history of computation lived and died centuries or decades ago. I call these people, renowned in scientific circles but less well known to the public, the patriarchs. Other co-creators of personal computer technology are still at work today, continuing to explore the frontiers of mind-machine interaction: the pioneers.

The youngest generation, the ones who are exploring the cognitive domains we will all soon experience, I call the infonauts. It is too early to tell what history will think of the newer ideas, but looking at some of them may provide clues to what (and how) everybody will be thinking in the near future.

As we shall see, the further limits of this technology are not in the hardware, but in our minds. The digital computer is based on a theoretical discovery known as "the universal machine," which is not actually a tangible device but a mathematical description of a machine capable of simulating the actions of any other machine. Once you have created a general-purpose machine that can imitate any other machine, the future development of the tool depends only on what tasks you can think up for it. For the immediate future, the issue of whether machines can become intelligent is less important than learning to deal with a device that can become whatever we clearly imagine it to be.

The pivotal difference between today's personal computers and tomorrow's intelligent devices will have less to do with their hardware than their software—the instructions people create to control the operations of computing machinery. A program is what tells the general-purpose machine to imitate a specific kind of machine. Just as the hardware basis for computing has evolved from relays to vacuum tubes to transistors to integrated circuits, the programs have evolved as well. When information processing grows into knowledge processing, the true personal computer will reach beyond hardware and connect with a vaster source of power than that of electronic microcircuitry—the power of human minds working in concert.

The nature of the world we create in the crucial closing years of the twentieth century will be determined to a significant degree by our attitudes toward this new category of tool. Many of us who were educated in the precomputer era will be learning new skills. The members of the college class of 1999 are seven years old, and already on their way toward new realms of linguistic power. It is important that we realize today that those skills of tomorrow will have little to do with how to operate computers and a great deal to do with how to use augmented intellects, enhanced communications, and amplified imaginations.

The possibility of accurately predicting the social impact of any new technology is questionable, to say the least. At the beginning of the twentieth century, it was impossible for average people or even the most knowledgeable scientists to envision what life would be like for their grandchildren, who, as it turned out, sit down in front of little boxes and watch events that are happening on the other side of the world.

Today, a few people are thinking seriously about what to do with a living room wall that can simulate anything you want to see, connect you with any person or group of people you want to communicate with, tell you almost anything you want to know, and even help you figure out *what* you want to know. In the 1990s, it might at last become feasible for people to "think as no human being has ever thought" and for computers to "process data in a way not approached by the information-handling machines we know today," as J. C. R. Licklider, one of the most influential pioneers, predicted in 1960, a quarter of a century before the hardware would begin to catch up with his ideas.

The earliest predictions about the impact of computing machinery occurred quite a bit earlier than 1960. The first electronic computers were invented during World War II by a few unusual individuals who often worked alone. Before the actual inventors of the 1940s came the software patriarchs of the 1850s. And before them, thousands of years ago, the efforts of thinkers

from many cultures to find better ways to use symbols as tools led to the invention of mathematics and logic—formal systems for manipulating symbols that eventually led to computation. Links in what we can now see as a continuous chain of thought were created by a series of Greek philosophers, British logicians, Hungarian mathematicians, and American inventors.

Most of the patriarchs had little in common with each other, socially or intellectually, but in some ways they were very much alike. It isn't surprising that they were exceptionally intelligent, but what is unusual is that they all seem to have been preoccupied with the power of their own minds. For sheer intellectual adventure, many intelligent people pursue the secrets of the stars, the mysteries of life, the myriad ways of using knowledge to accomplish practical goals. But the software ancestors sought particularly to create tools to amplify the power of their own brains—machines to take over what they saw as the more mechanical aspects of thought.

The characters whose thoughts and creations resulted in the invention of the computer included enough true eccentrics for a television soap opera. In the 19th century, Charles Babbage, a notoriously cranky, brilliant, eccentric British aristocrat, and his equally talented and eccentric (if somewhat less cranky) accomplice Ada, Lady Lovelace, nearly invented the computer a century before a monstrous array of vacuum tubes known as ENIAC (Electronic Numerical Integrator and Calculator) surged into history in an overheated room in Pennsylvania. Babbage, exasperated by the inaccuracies he found in logarithm tables, vowed to build a machine for performing laborious calculations rapidly and flawlessly. Ada, after whom the U.S. Department of Defense named its primary programming language, is widely acknowledged to have been the first programmer. Together, they came up with a programmable calculating machine that could perform logical as well as arithmetical operations; the mechanism for conveying instructions to the machine was a series of punched cards, similar to those used to program the patterns of automatic looms.

A few decades after Babbage and Lovelace, an impoverished teacher of mathematics in a British secondary school literally fell to the ground one day, thunderstruck by an idea that was later to become very important in the evolution of computation. Walking across a moor at the age of nineteen, George Boole saw a way of applying the procedures of algebra to the mathematical solution of logical problems. He thought he had discovered the *Laws of Thought,* as he named his book—which was a mistake, since logic has little to do with the way living human beings conduct their mental affairs. But he had discovered something that would become indispensable when the computer builders came along, a mathematical-logical tool known today as

Boolean logic. This momentous discovery rested in obscurity for decades, another example of those hopelessly abstract things mathematicians do that could never possibly have any application in the real world. A half-century later, it was rediscovered by Claude Shannon, a young M.I.T. student, who realized that it was a perfect tool for analyzing and predicting the behavior of large networks of electrical circuits—the kind of electrical networks that are necessary parts of computers.

The final insight that brought together all the bits and pieces of knowledge needed to make computing possible was not the result of a concerted effort by an inventor or engineer, but a side effect of a thought experiment conducted by another eccentric British genius, Alan Turing. Turing's work was rooted in the abstruse and obscure field of metamathematics (unknown to most of the world), which sought solutions to some of the grandest questions humankind has ever pondered, about the nature of knowledge and the certainty of the knowledge we can have about the world.

In the process of clearly delineating the boundaries of mathematical knowledge (which, after all, is the basis of scientific knowledge, and thus the theoretical foundation for most of industrial civilization's temporal power), Turing came up with the notion of a "universal machine," one that could imitate the actions of any other machine that could be clearly described. The workings of the Turing machine, as it has come to be known, were described in a mathematics paper Turing published in 1936, when he was only twenty-two. Together with Boolean algebra, the notion of a Turing machine provided the theoretical bases for true mechanical computators, which weren't invented until a decade later.

If necessity is the mother of invention, warfare is certainly the father of technology. The first computer was invented at the University of Pennsylvania during World War II, under a contract from the Department of Ordnance, for the production of mathematical tables for artillery. Indeed, it might be said that both the human brain and the electronic computer evolved out of the human impulse to throw things at each other. If you want to hit a moving target at a distance with a small projectile, you have to do some complex calculations very quickly. If you are throwing a rock, your brain mechanisms take care of the calculations automatically. If you are firing an artillery shell, you have to consult a firing table calculated for that gun and that shell. (Another wartime project was involved with automatic aiming devices that would allow the firing table to be built into the gun, a research effort that spawned the field of cybernetics.) By the middle of the war, so many new guns and shells were coming out of the factories that a small army of human calculators (already called "computers") was required. ENIAC, the first

electronic digital computer, solved the army's problem. Thanks to ENIAC's inventors, especially John von Neumann, the project's sponsors were persuaded to fund further research on other, nonballistic applications for the newborn technology.

If you asked ten thousand people to name the most influential thinker of the twentieth century, it is not likely that one of them would nominate John von Neumann. Few would even recognize his name. Despite his obscurity outside the communities of mathematicians and computer theorists, his thinking had incalculable impact on human destiny. He died in 1957, but the fate of the human race still depends on how we and our descendants decide to use the technologies von Neumann's extraordinary mind made possible. He was a key member of the revolution in quantum physics that led to the nuclear age; a key member of the Manhattan Project; a key member of the ENIAC team and the foremost theorist in the first years of computer science; a top Department of Defense advisor and a key member of the ICBM Committee. Not the least of his insights about the future of computation was that the computer was (1) a logical as well as a mathematical device, and thus capable of emulating human reasoning processes, and (2) a potentially momentous tool for any kind of thinker whose field requires calculation and logical manipulation.

In 1960 J. C. R. Licklider, an M.I.T. professor, published a paper with the curious title "Man-Machine Symbiosis." In it he set forth the concept of the kind of human-computer relationship that he was later to be instrumental in initiating:

> The fig tree is pollinated only by the insect *Blastophaga grossorum.* The larva of the insect lives in the ovary of the fig tree, and there it gets its food. The tree and the insect are thus heavily interdependent: the tree cannot reproduce without the insect; the insect cannot eat without the tree; together, they constitute not only a viable but a productive and thriving partnership. This cooperative "living together in intimate association, or even close union, of two dissimilar organisms" is called symbiosis.
>
> "Man-computer symbiosis" is a subclass of man-machine systems. There are many man-machine systems. At present, however, there are no man-computer symbioses The hope is that, in not too many years, human brains and computing machines will be coupled together very tightly, and that the resulting partnership will think as no human being has ever thought and process data in a way not approached by the information-handling machines we know today.[2]

Licklider started out doing research in the field of psychoacoustics, exploring the ways electronics and computer mechanisms could be applied to the task of understanding human communications. But he found that the mathematical and electronic models he was building began to get more and more complicated and took up more and more of his time. He started thinking about using computers, and about how much of his time was really occupied by thinking and how much of his day was devoted to tasks that slightly intelligent machines could handle.

In the spring of 1957, while he continued to carry out the duties of a researcher and professor, Licklider noted every task he did during the day and kept track of the time he spent on each one. He didn't know it then, but that unofficial experiment prepared the way for the invention of interactive computing—the technology that bridged yesteryear's number-crunchers and tomorrow's mind-amplifiers. In the winter of 1957, the U.S.S.R. launched Sputnik and the U.S. Defense Department launched a new wave of research; through a series of circumstances, Licklider became the director of the Information Processing Techniques Office of the department's Advanced Research Projects Agency (ARPA).

Licklider sought computer scientists and programmers in universities around the country, to create a new state of the art in human-computer and computer-to-computer communications. Ultimately, the result of this effort was the technology that forms the basis for affordable personal computing. When it became necessary for the scattered ARPA researchers to share research data, and even send computer data and programs from one machine to another, Licklider's successor, a young NASA funder named Bob Taylor, coordinated the effort to create the first computer network, ARPAnet.

To the surprise of the people who had overseen its creation, the ARPAnet took on a life of its own. The implications of phenomena like electronic mail and topic-oriented on-line conferences were not lost on Licklider and Taylor. In 1968, they published an article entitled "The Computer as a Communication Device," boldly (and chauvinistically) declaring in the first sentence: "In a few years, men will be able to communicate more effectively through a machine than face to face." The idea that a new kind of community could be brought about by the use of a new kind of computer system was the most radical proposal in the article. Looking toward the long-term future, when the technology would become affordable and widespread throughout the general population, Licklider and Taylor predicted the profound social impact of computer-linked communities that might include not only computer scientists and programmers but artists, engineers, housewives, schoolchildren, office workers, designers, librarians, and entertainers:

But let us be optimistic. What will on-line interactive communities be like? In most fields they will consist of geographically separated members, sometimes grouped in small clusters and sometimes working individually. They will be communities not of common location, but of *common interest*. . . .

First, life will be happier for the on-line individual because the people with whom one interacts most strongly will be selected more by commonality of interests and goals than by accidents of proximity. Second, communication will be more effective, and therefore more enjoyable. Third, much communication will be with programs and programmed models, which will be (a) highly responsive, (b) supplementary to one's own capabilities, rather than competitive, and (c) capable of representing progressively more complex ideas without necessarily displaying all the levels of their structure at the same time—and which will therefore be both challenging and rewarding. And fourth, there will be plenty of opportunity for everyone (who can afford a console) to find his calling, for the whole world of information, with all its fields and disciplines, will be open to him—with programs ready to guide him or to help him explore.

For the society, the impact will be good or bad, depending mainly on the question: Will "to be on-line" be a privilege or a right? If only a favored segment of the population gets a chance to enjoy the advantage of "intelligence amplification," the network may exaggerate the discontinuity in the spectrum of intellectual opportunity.

On the other hand, if the network idea should prove to do for education what a few have envisioned in hope, if not in concrete detailed plan, and if all minds should prove to be responsive, surely the boon to humankind would be beyond measure.[3]

Which brings us to the present. The following section is a brief peek at one of the living on-line communities that exist today, two decades after Licklider and Taylor speculated about them.

The Well: Introduction to a Virtual Community

I know how the pioneers and infonauts feel when they work all night, week after week, year after year, to materialize a mind-tool they dreamed about using themselves. Mind-tool fever is infectious, and I caught it early in the game. In the late 1970s, when Apple Computer was a small operation in a single building, I interviewed a fellow who worked for Apple because I had heard that he had programmed his computer to act like an electronic typewriter. I didn't know at that time about the efforts of Doug Engelbart, just a few miles from the Apple building. But I had a dream about the "writer of tomorrow."

Tomorrow's writer, I fantasized, wouldn't use a typewriter and a library, but would perform sophisticated editing functions electronically, manipulating words of light displayed on a television-like computer screen instead of scratching out and writing over inked impressions on paper pages. And when it came to information gathering, the writer of tomorrow would use a computer and a telephone line to plug into up-to-the-minute databases stored on main-frame computers hundreds or thousands of miles away.

The way I saw it then, the writer of tomorrow would be a kind of alchemist who would transmute information into knowledge. All the facts and fictions, images and ideas, statistics and speculations would flow in through the telephone line, via my computer. My interpretation of what it all *means* would flow out of my home and find its way to the minds of my readers through the

same telephone lines and a network of information terminals in every private home and public institution in the land. It was quite a grandiose fantasy. Little did I know that it had existed in certain rarefied circles for years.

Back in the 1970s, I had heard of the ARPAnet and had even met a few computer scientists who routinely used it for electronic mail. But these technologies were far beyond the reach of the average free-lance writer. The Apple II, puny as it was by today's personal computer standards, was the first indication that it might soon be possible for artists and writers and business people to use computerized research and writing tools. Unfortunately, none of the magazines I wrote for at that time were interested in publishing my interview with the Apple employee. All the editors said more or less the same thing: "Nobody but writers will be interested in this stuff." Less than five years later, the office automation revolution irrevocably changed the way business is done in the very offices those editors work in.

When I was researching *Tools for Thought* and met Bob Taylor, I read with enthusiasm the earliest predictions he and J. C. R. Licklider had made in the 1960s for the "on-line communities" they foresaw for the 1980s and beyond. The people who were responsible for creating the technology that today links computers and people together into vast networks were concerned about the social potential—and the potential for abuse—of this new computer-linked form of human communication and organization. They knew from experience with the ARPAnet that the technology spawns its own social consequences, often utterly unexpected even by those who designed the system. For example, the original linkage of remote computers was directed toward the problem of sharing data and programs, not personal messages, but the first people to use the system (who were also the people who were building the system) spontaneously exchanged messages about topics that had little or nothing to do with the technical agenda. Electronic mail, which is currently the hottest growth technology in the office automation revolution, was originally an unintended social side effect.

When the first on-line communities that included people who weren't exclusively computer science researchers began to emerge in the late 1970s and early 1980s, they came from a direction that Taylor and Licklider had not anticipated. The first computing machines that ARPA researchers used were "time-sharing" machines, which meant that the various researchers all used terminals connected with a central computer that was generally in the same room or building or campus as the terminals; each user shared the central computer with many other users. When the electronic miniaturization revolution made personal computers economically feasible (i.e., computer systems with significant power, devoted solely to the use of one person), large

research organizations (like Taylor's employers at Xerox) began to exploit the idea of "local area networks" as office automation tools. Neither the research pioneers nor the big manufacturers anticipated the widespread use of small, inexpensive computers like the Apple, nor their eventual interconnection via telephone lines into ad-hoc networks known as "bulletin board systems."

A bulletin board system, or BBS, is a computer of any size that is connected to a telephone line via a modem (a device for translating computer-originated words, numbers, programs, and images into electronic impulses that can travel along common-carrier channels). It is connected to the telephone line and "listens" for calls, while the *host* computer runs a special kind of software that enables people to dial into the BBS, read (or *download*) information, and write (or *upload*) information to the host computer. If people want to exchange software, for example, they can call the BBS, download a program that someone else has previously uploaded, and then run it on their home computer after they disconnect from the BBS.

Many BBSs exist for the purpose of exchanging what is known as "public domain" software, programs that do various entertaining or useful tasks for personal computer users. But many of them exist as a kind of electronic forum, a community debating, message-exchanging entity. In these BBS systems, the computer itself ceases to be the focus of interest, and is used as a new kind of human communication medium as well as a transfer device for distributing software. Unlike other communication media—where the communicator always knows with whom he or she is talking (like the telephone), or where the information provider reaches a large audience that doesn't communicate back (radio or television), or where the information provider gives out information on a regular basis in a fixed format (newspapers)—BBS systems, or computer conferencing, as it is sometimes called, offer an interactive, asynchronous method of communicating with a large number of people who don't know you but share your interests.

The early BBS systems tended to be oriented toward one general field of interest per computer, from fantasy games to computer programming, from sex or jokes to politics or religion. The office automation specialists had been working long and hard on the premise that electronic communication via computer networks would be an important tool in the business world, the way the telephone had been at the beginning of the century. But nobody had foreseen that people would set up their own communication networks voluntarily, from the sheer joy of discussing country and western music, debating political issues, trading technical information, lobbying Congress, designing better BBS programs, composing on-line soap operas, selling tickets to Bach or rock concerts. Although the educational significance of this

phenomenon was lost on all but a few educators, part of the "de-schooling" of education predicted by Illich and others was already happening. People were trading expertise, contributing tidbits of specialized knowledge, groping their way toward a kind of narrow-bandwidth group mind.

The bandwidth—the volume of information that can be pushed through a communication channel like a computer screen—of computer conferencing is much narrower than the bandwidth of a face-to-face meeting between a group of people. Visual cues like facial expression, auditory cues like changes in tone of voice, even olfactory cues, are totally absent from a conversation that involves the exchange of typewritten messages displayed on a computer screen. But it was precisely this narrowness that was so attractive to early aficionados. Your age, gender, race, appearance, and other characteristics that are obvious when you are physically present simply aren't perceptible in a computer conference. As a consequence, your words determine your identity in the minds of those who read them. What you say, how you say it, and the circumstances in which you tend to say something are all anyone knows about you. You can construct a new identity for every BBS. You can even use a different name; pseudonymous contributions were born with the medium and have never quite gone away.

The anonymity and the encouragement of comment, criticism, and feedback, coupled with the feeling that a large audience is looking over your shoulder and is able to construct models of "who you are" by reading your various remarks, seems to liberate the urge to wisecrack. Individuals and entire on-line communities undergo a progression of stages in the evolution of communication behavior. Group discussions can hover between graffiti battles and good-natured one-upmanship on the lighter side, and on the more serious side, heated debate and Socratic dialogue. If you think of a human personality as many different "voices" that contribute their opinions at various times (e.g., the emotional voice, the rational voice, the intuitive voice, the instinctive voice), it is easy to see bulletin boards as group personalities that are made of, but different from, the sum of the individual participants.

Bulletin board systems that host many different kinds of interests tend to organize communications by interest group (in the very large telecommunication services like the Source and CompuServe, these are known as SIGs, or special interest groups). You can scan a list of discussions and decide to explore mathematics, debate foreign policy, ignore folk dancing, drop in on the gardening discussion, avoid the philosophy forum, and visit the spirituality conference. The difference between this mode of organizing communication and regular mail or telephone networks is that in the telephone

network you have to know who you are trying to call, and you have to obtain their telephone number before you can get your message across, and if you write a letter you have to put an address on the envelope before you can mail it, but in computer conferencing, *the content of the message is the address:* "To everybody else who wants to trade information about running a one-person business (or automobile repairs, or classical music . . .)."

By making the message the address, BBSs make the topic, rather than the identity of the discussants, the center of a discussion (thus fulfilling Licklider's and Taylor's forecast of communities held together solely by common interests). They create a kind of virtual social space—a series of messages that is designed to draw a response from persons unknown, now or in the future, whose only common characteristic is a shared interest in a specified topic. Like a bulletin board in a room where people visit, read, and write—one person at a time—the discussion can be free-form, with people dropping in and out sporadically for months and years. In most systems, the identification of the respondent is displayed on the computer screen of the person who is reading through the record of such a conversation, along with every response, and the time of each response. If you know the user ID of someone who seems to share your interests or point of view, most systems provide you with a short biography, straightforward or fanciful, that the person has composed. Then you can send that person private mail that is not readable by everyone else, as are conference responses.

Most BBSs also post lists of telephone numbers of other BBSs, so once you stumble into the telecommunication dimension, you can quickly zero in on your particular area of interest. In many cases, the sharing of opinions, the matching of wits, the humor, anger, warmth, caring, and planning are the true area of interest, no matter what the formal topic of the discussion might be. In other words, there is an invitation to an exploration of the community that seems to be inherent in the medium itself; it is a seemingly impersonal forum that invites surprisingly intimate social encounter. In the *Harvard Business Review* (January–February 1986) sociologist Sara Kiesler, in her article "The Unintended Side-Effects of Computer Conferencing," notes that whenever companies set up computer message systems for the efficient interchange of electronic mail, people start interacting in ways they never tried before, and the discussions always seem to stray, at least part of the time, away from the matters of business at hand.

After discovering BBSs, I checked in on several of them from time to time. Although I occasionally contributed a comment or a reference or piece of knowledge to one or the other, I didn't connect with a virtual community of my own until 1985, when I joined the **W**hole **E**arth 'Lectronic **L**ink ("the

Well"), a system that runs on a fairly powerful computer in the San Francisco Bay area. The host computer is a "Vax," and it is more powerful than the kind of personal computer commonly used for a BBS. A BBS on small personal computers is like a telephone booth in that only one person at a time can connect with it. Although many people can read and write messages over a period of hours or days, only one of them can do so at any one time; the rest of the members of the community find their access blocked by a busy signal. A Vax, however, with the proper peripheral hardware and conferencing software, allows dozens of people to interact with the system and with each other at the same time.

I was attracted to the Well because of the local flavor and social diversity of the community. At the time I joined, there were around two thousand members, most of them from the San Francisco Bay area. Stewart Brand, publisher of the Whole Earth Catalog and founder of the Well, had attracted an eclectic group, ranging from Tim Leary to William Randolph Hearst III. Because the rates are relatively low—three dollars an hour plus the price of a local phone call—the population of users isn't restricted to the wealthy hobbyist or computer professional. Because the San Francisco area is so close to Silicon Valley, a large number of very sophisticated programmers were charter members, which makes it quite convenient when something goes wrong, or when somebody thinks of a new feature to add to the system.

The computer conferencing software, known as Picospan, allows people to move from conference to conference, and from topic to topic, reading strings of responses in linear order or jumping around. It also provides tools for creating responses, or storing longer essays in file areas where other people can read them, or even sharing computer programs. Following is a brief foray into the Well. When my personal computer dials the host computer and my communication software reads my password to the host computer, I can request a list of currently active conferences, which will display on my screen:

Conferences on the WELL

The real world

Vacation Video (go vac)	Jokes (g jokes)	Politics (g pol)
Garage—autos (g gar)	Music (g mus)	Writers (g wri)
	Legal (g leg)	Science Fiction (g sf)
Medical (g med)	Spirituality (g spi)	Desktop Publishing (g desk)
Games (g game)	Photography (g pho)	
	Sexuality (g sex)	Education (g edu)

36

Movies (g mov)
Business (g biz)
The Examiner (g ex)
Earthstewards (g ear)
Free U (g free)
Curious ?'s (g que)
Stock Market
 (g stock)
Library (g lib)
On The Air (g on)
Mind (g mind)
Parenting (g par)
Electronics (g ele)
Success (g suc)
Grateful Dead (g gd)
Fine Arts (g fine)
The Art Com
 Electronic Network
 (g acen)
Peace (g pea)

Classifieds (g cla)
Eating (g eat)
Calendar (g cal)
Video (g vid)
Liberty (g liberty)
Management
 (g mana)
Space (g spa)
Sports (g spo)
Psychology (g psy)
Outdoors (g out)
Aging (g age)
Home Repair (g rep)
Rasslin (g ras)
Women in Telecom
 (g wit)
The Corner Pub
 (g pub)
Environment (g env)
Fun (g fun)

Gay (g gay)
Travel (g tra)
One Person Business
 (g one)
Philosophy (g phi)
Languages (g lang)
Magazine Publishing
 (g mag)
Whole Earth
 Symposium
 (g wes)
The Future (g fut)
Technical Writers
 (g tec)
Art Directions (g art)
Role Playing Games
 (g rpg)
Human Resources
 (g hum)
Gardening (g gard)

Computers

IBM PC (g ibm)
Commodore (g com)
Macintosh (g mac)
Laptop (g lap)
CP/M (g cpm)
Apple & Dtack
 (g app)
MicroPro (g mic)
Kaypro (g kay)
Power Users (g pow)
Forth (g for)
Amiga (g amiga)
Spreadsheets (g spr)
Databasics (g dat)

Programming
 (g prog)
Unix (g unix)
Programmers Net
 (g net)
AI (g ai)
Learning (g ed)
Microtimes
 (g microx)
Enable (g ena)
Atari (g ata)
Telecommunications
 (g tel)

Fido (g fido)
Hackers/Homebrew
 (g home)
BMUGSIG (g bmug)
Currents in the well
 (g cw)
Packet Radio (g pac)
Whole Earth
 Symposium
 (g wes)
Computer Books
 (g cbook)
Framework (g fra)

System news Help (g help) Hosts (g hosts)
 (g news) Manual (g manual) Entry (g ent)
General (g gen)

Ok (? for help): go mind

* * *

The listing of conferences shows the different discussion areas that are currently active. The message shortly after the list is called "the prompt," and the words *go mind* after the prompt indicates my command to the host computer to display the current activity in the mind conference. Although each conference is open to contributions from every member of the Well, each conference is informally hosted by one person, known as a "fairwitness," who is usually the person who came up with the idea of having a conference on a specific topic.

* * *

Welcome to Mind

What it is is up to us.

Host: Howard Rheingold (hlr)

Type browse at the OK prompt for a list of topic headers.
Type mind at the OK prompt to see a menu of mind documents.
Type s1 at the OK prompt for a brief intro to the mind conference.

1 newresponse item
First item 1, last 40
You are a fair-witness in this conference.

* * *

You can think of the Well as a building with many rooms in which discussions are going on, and the Mind conference as one of the rooms. Imagine that the "header," or the introductory descriptive message of each topic, is written on a piece of paper that is suspended from a clothesline, perhaps with a (virtual) clothespin. When someone else "enters" the room and reads that introductory message, he or she might be moved to respond by pinning a message under yours. Thus, every topic has a unique identifying number and header, and every response has a unique identifying number. Besides the content of the message, the system displays the name of each message's author, and the time the message was posted.

Whenever I enter the Mind conference, Picospan shows me only those responses that have been added to any of the discussions since the last time I entered the conference.

* * *

Topic 39: You've Probably Seen This Topic Somewhere Sometime
By: Dan Levy (danlevy) on Wed, Jun 25, '86
19 responses so far

2 new of 19 responses total.

Topic 39: You've Probably Seen This Topic Somewhere Sometime
#18: Lila Forest (lila) Thu, Jun 26, '86 (12:30) 3 lines

I heard a theory once (which I intuitively reject) that deja vu is a random replaying of short-term memory as it is being stored in longterm memory—sort of a glitch in the file-copying process, so to speak . . .

Topic 39: You've Probably Seen This Topic Somewhere Sometime
#19: MATTHEW McCLURE, WELL (mmc) Thu, Jun 26, '86 (12:53)
2 lines

I think it's a pattern-recognition phenomenon . . .

(r)espond, (p)ass, or ? for help: r

* * *

I decide to respond. When I type "r," the system automatically puts my keyboard in control of a simple line-oriented text editor. The line numbers accompanying the text allow the writer to make changes before saving the message (adding it to the permanently stored record of the conference).

* * *

Use "." or ^D to end.
1:
I seem to remember that there is a connection between the olfactory bulb,
2:
which is one of the (evolutionarily) oldest parts of the brain, and a
3:
brain structure associated with memory. Certainly seems to be true that
4:
certain smells can trigger hyper-realistic "memories" of sometimes

vaguely defined places and times.
6:
Edit command (? for help): s

* * *

 The editing commands allow me to abort the message, in which case it will not be posted, or save the message, in which case it will be posted for others to read (which is what I do by typing the letter "s"). Other commands make it possible for me to upload a file that I had edited offline or copied from another BBS, or to read into the reply a file that I have stored somewhere in the host computer.

 Next, I decide to go back to the beginning of the first topic, to replay the introductory message that all new participants read when they join the Mind conference.

* * *

OK (? for help): s1

Topic 1: Welcome to Mind.
By: Howard Rheingold (hlr) on Sat, Jan 25, '86
 9 responses so far

This conference is about Mind in the largest sense. Here we get to talk about all the hybrid fields like cognitive science and oddball experiments like lucid dreaming and outright speculation about groupminds and intelligence enhancement, belief systems and extraordinary powers, the origins of consciousness and the future of consciousness expansion. The only rules are the rules of etiquette for this medium. Debate is encouraged. It will be less boring for those of us following a particular thread if flamethrower duels are moved to the Asbestos Arena—go there to slug it out. Other than that, it's up to all of us. From time to time, you or I will upload relevant or irrelevant documents. The conference index (type "display index" at the prompt) will direct you to these archives.

 I can't imagine where this topic would go, beyond this general welcome, but that is up to the rest of you. If you want to raise any issues or ask any questions about getting around in the conference or anything else, send mail to (hlr).

 Mind—ya can't live with it, and ya can't live without it.

 Let's get out of it, into it, and on to it . . .

 howard rheingold (hlr)

9 responses total.

Topic 1: Welcome to Mind.
#1: Howard Rheingold (hlr) Sat, Feb 1, '86 (22:48) 5 lines

NEWCOMERS TO THE WELL: Some helpful advice from David Hawkins on how to get the most out of Picospan (this conferencing system) is available through the Mind menu. Type mind at any prompt, then follow the instructions.
—howard

Topic 1: Welcome to Mind.

#2: Donald Simon (love) Thu, Mar 20, '86 (03:52) 2 lines

Howard, whats considered an unsuitable response length on this conference. I've been chided recently in the spirituality conference for going beyond 15 lines.

Topic 1: Welcome to Mind.
#3: Howard Rheingold (hlr) Thu, Mar 20, '86 (09:04) 13 lines

Donald,

 I strongly feel that we should not exercise prior restraint on what people write and how long they write. It would be a courtesy to readers to remind them that you are going to write at length—even though it displays the number of lines in the header, many people don't look at the header. That way, they can Control-C their way out of the response, after noting its number, then return to the next response. I would say that if you are going to run over 25 or 30 lines you might want to upload your piece to the Mind archives and post notices in appropriate topics. There is a topic on how to submit longer pieces to the archive. Now that you have our curiosity aroused, where is that long response?
—howard

Topic 1: Welcome to Mind.
#4: Donald Simon (love) Thu, Mar 20, '86 (22:08) 2 lines

Its in the MIND. We will install a mind to finger interface soon.

Thanks much for the info.

Topic 1: Welcome to Mind.
#5: Thor Challenger (omega) Fri, Mar 21, '86 (20:28) 2 lines

Is the mind to finger interface a subset of the finger to nose protocol?
(******)

#6: Donald Simon (love) Sat, Mar 22, '86 (00:15) 8 lines

Thor you are confusing protocol with hardware. The new unit will have its own built-in central processing unit and read only memory. Therefore it will be a smart interface. Because it is both capable of internal and external programming we should have alot of fun with it. You are refer-ring to the level TCP/IP level 9 nose to finger protocol. We plan to add this as plug-in peripheral as the need arises. In the meanwhile we are involved in working out the bugs in the system. Will let you know when the data error rate approaches 0.

Topic 1: Welcome to Mind.
#7: david gans (maddog) Wed, Mar 26, '86 (15:20) 2 lines

Is this a robotics thing or anthropomorphism or bionics??

Topic 1: Welcome to Mind.
#8: Howard Rheingold (hlr) Wed, Mar 26, '86 (15:40) 1 lines

What it is is up to us.
 * * *

 At this point, I exercise my option to bail out of my last command and go to the respond or pass prompt without reading all the intervening messages. As you can see, the conversation can consist of light, short, not terribly significant banter. It can also consist of more serious discussions that can include quotes and footnotes and references and all the other paraphernalia of scholarly discourse. In order to see the list of all the current Mind topics (any member can add a new topic at any time), I type "b" to "browse" the topic headers.

 * * *

(r)espond, (p)ass, or ? for help: p

Ok (? for help): b

item / number of responses / header

1 9 Welcome to Mind.

2 80 About the Mind Conference: Metatopic Stuff Here

3 82 Augmenting Human Intellect: From Computers to Mind Ampli-fiers.

4 23 The Information Processing Model: Computation as a Probe of Cognition

5 104 Weird Thoughts Registry: When There is No Place Strange Enough to Say it.

42

6 60 Noetic Sciences: The Parts of the Mind the Psychologists Don't See (Yet)

7 84 Groupminds and Online Communities

8 46 ASBESTOS ARENA: MOVE YOUR FLAMETHROWER DUELS HERE, PLEASE, YOU #%&!*

⟨item is frozen⟩

9 34 Neuroscience: Hardware, Wetware, and Software

10 65 Extraordinary (but Demonstrable) Human Abilities

11 17 The Community File—Edit and Add

12 16 Mind? What's that? Conflicting or convergent definitions.

14 60 Dreams and Dreamwork: Experiments in the Other Dimension

15 36 Wellbeam

16 11 Calendar of events related to mind/intelligence/etc.

17 125 FLAME PIT: NASTY REJOINDERS, FIGHTS, ETC.,

18 23 Other corners of the mind

19 66 Inventing a Multiplayer, Multimind Game

20 1 The Mind archives—how to read and submit longer articles.

21 106 Shady's place—Q and A with a Cosmic Entity

22 0 Invitation to Grateful Dead Conference—Mind Welcome

23 44 Mind and Music

24 28 ELF VLF Bio-entrainment, and Harmonics . . . What is possible?

25 12 A Democratic Alternative to Voting.

26 19 The Well in the Year 2000—Scenarios, Fantasies, Dreams

27 0 Prolog and Expert Systems Book Help Request

28 10 THE FUTURE OF ON-LINE COMMUNICATIONS: German Writer wants to know.

29 47 Word Viruses

30 40 Grateful Dead Concerts As Groupmind Experiments?

31 53 intuition in business

32 21 TIMOTHY LEARY IS BACK

33 28 Speechless

34 77 MIND GAME 1 (MG1)—A Multiplayer Treasure Hunt

35 10 Mind poems like earth flowers

36 3 Learning Solo versus Together

37 6 Artists out of their mind

38 11 Hologram

39 20 You've Probably Seen This Topic Somewhere Sometime

40 11 Untranslatable Words: The Cracks Between the Worldviews

The slice of online life presented above is just a slice: along with the metaphysical, social, and downright silly threads of thought are serious de-

bates and discourses; and on another level that is not available through other media, all participants have instant access to longer documents contributed by other participants. Thus, the line between "audience" and "information provider" is semipermeable. Writing becomes a performing art, community becomes invisible but heartfelt.

It takes a certain kind of person to master and become infatuated by the kind of virtual community to be found on BBSs. Because all communication is in terms of the written (typed) word, the medium is heavily weighted toward those who can write clearly and forcefully. This is a temporary artifact of the early state of this technology's evolution: store-and-forward mail systems for voice messages already exist; with the faster, vaster computer memories that will be available in the coming years, as well as the high-bandwidth network communication media such as fiber optics, the computer conferencing medium will pop into living color and three dimensions. Imagine a conference like the one we just looked at, except the participants have the option of making their responses via video and sound images, or animated images, and including both sound effects and processing effects.

When the high-bandwidth networks of the future become available, the community will still be a virtual community, because each participant will have the option to display his or her "real" image, or to substitute a cleverly crafted representation of some kind. Indeed, creating one's own representation forces every member of the community to become an artist as well as a communicator, and the system should be able to provide drawing, animating, sound-synthesizing tools to make that artistic expression available to the widest possible audience, not just to those skilled in visual arts. What effects this medium-to-be will have upon the world are impossible to predict with any precision, but those effects are likely to be more profound and far swifter than anyone can predict today. With the prospect of universally available universal machines, the human species is on the brink of a new stage of evolution. What it is, ultimately, is up to us.

Notes

1. New York: Simon and Schuster, 1985; Prentice-Hall, 1986.
2. J. C. R. Licklider, "Man-Machine Symbiosis," *IRE Transactions on Human Factors in Electronics* HFE-1 (March 1960): 4.
3. J. C. R. Licklider and Robert Taylor, "The Computer as a Communication Device," *International Science and Technology* (April 1968): 30.

Computer Graphics

and Artistic Ideas

DUANE M. PALYKA

Practitioners in the computer graphics field are commonly separated into two distinct groups—artists and scientists. I believe that artistic and scientific traits can easily coexist in an individual; I dislike the fact that we are forced to choose to become one or the other, and that we evaluate and categorize each other depending upon which we are. In all environments where I have worked or studied—places where artists and programmers bump elbows constantly—problems always occur because artists and programmers simply don't talk to each other enough. Thus many cross-disciplinary ideas remain stuck in their original area for a long time. In my field, this communications breakdown has hurt the design of computer graphics systems.

The tools of computer graphics have had many years of scientific development by the time the artist enters the picture. When the artist gets the tools, they are already imbued with the attitude of the programmer toward the art process. This attitude, which may or may not be acceptable to the artist, is based upon the kinds of tools the programmer has observed artists using in the past. The artist usually doesn't know what is technically possible in this medium, therefore doesn't know what to ask for, and accepts whatever is provided.

On the other hand, one may say that all tools in our culture are presented to us in this fashion. When artists buy paints, they don't specify how much pigment should be suspended in the oil, or even what pigments should be used. The chemists make those decisions, and the artists make their selections afterward. However, in the computer graphics area, the tools are much more complex and changeable than the simple ones used in other processes. In both cases, the physical hardware is fixed; in the paint-and-brush case, *everything* is hardware, but in computer graphics the hardware is basically

process-independent. It can be molded in many different directions. It is the software added to the hardware that establishes what the computer will do for the person using it, and its function can change drastically from business applications to horoscope calculations to painting programs. Furthermore, software is so malleable that a good program design can even allow the code to be customized to the person using the system.

Since the artist is the perpetual outsider—the divergent thinker always seeking to create that which is *other* than what has already been accepted—this should be an ideal medium. And it can be, if the software match is made properly. One problem is that it takes a lot more work to design a tool that is malleable rather than just usable. In order to customize this tool for their "unusual purposes," artists must work within the logic that forms the construct of the tool. This means that they must get involved with something that closely resembles programming—if not the very skill itself. And this involves a structured way of thinking that most artists shy away from.

Artists who work with computer graphics often see this need and decide to learn programming skills. However, taking a course in computer science for the first time is often a traumatic event for them. They feel alienated in this new arena, with its strange words, its history of accumulated logical, linear thinking, and the elitist attitude of some of its members.

At the New York Institute of Technology I teach a course called "Introduction to 'C' Programming with Graphics Applications," which teaches basic programming skills to artists in an environment that is comfortable for them. The class is organized around the philosophy that the need to make images should drive the learning of programming tools, not the other way around. I don't attempt to teach all aspects of the 'C' language. I am more interested in showing artists how to associate the act of writing code with the making of images—not in creating a class of professional programmers. Although most of the students write adequate programs that make wonderful images, I accept the fact that a student may not create one functioning program during the entire semester. But at least that student learns what is involved in the programming process and has a better idea of what to request from someone whose job it is to develop tools for him during the course of a project. The positive side effect of the class is that the better students gain new skills with which to make a living. Artists always need job skills that make use of their talents. Now they can do one kind of art on a personal level and can make their living by programming computers.

The object of the computer graphicist should be to make an artistic interface that is not only unique to the artist but is invisible as well. Eugen Herrigel aptly describes the true essence of the artistic process: "The hand

that guides the brush has already caught and executed what floated before the mind at the same moment the mind began to form it, and in the end the [artist] no longer knows which of the two—mind or hand—was responsible for the work."[1] This invisibility is necessary for the artist to be able to translate his visual idea as simply as possible onto canvas (electronic or otherwise) with minimum translation into an intermediary linear, logical series of commands. Although the introduction of the logical level is an integral part of programming computer art, it interferes with the conventional drawing and painting process. The artist as draftsman works hard to bring his drawing skills up to the level where he doesn't have to think about them. At that point, the work better reflects his own individuality, and, if the artist is truly involved with his work on a deep level, the element described as "content" emerges.

The factor that concerns us here is the extra dimension added when the computer is inserted into the process. Programs can create interesting, repetitive mathematical effects and forms (both predictable and unpredictable), which add excitement to the work of art. However, this excitement is contained in images that did not flow directly from the artist's hand, but came from a more mechanical process that allows the artist only limited control. So, although the work may be creative or entertaining, it is also detached from the artist and is thus lacking in the kind of "content" described above.

Although artists have traditionally been involved with creating works that are based upon direct experiences and that, in turn, create direct experiences for the viewer, scientists have historically moved toward levels of intellectual abstraction and away from direct experience. As science evolved, scientists no longer directly observed phenomena, but observed instruments that observed phenomena. Their experience became that of interacting with instruments that observed events instead of experiencing the events themselves. To them this is a desirable situation, because the premise for their work is total detachment: the goal of the scientific method is to have the greatest possible separation of subject and object.

The field of mathematics, once the calculating tool of the physicist, actually separated into a totally separate field where it didn't have to rely on physical reality at all but could exist purely for intellectual amusement. With the advent of computing machinery, a situation evolved whereby abstract, detached mathematics could manifest images that resemble some sort of physical reality. Thus we have come to the point where, as with the artistic experience, direct experiences are created by abstract mathematics. The question is whether or not this abstract medium, several levels away from experiential reality, can provide images that are not in themselves detached. In other words, can these images have a lasting affinity for the viewer of these

works? Can a medium whose design is based on complete subject/object separation create a situation where the artist and his work become one? In our turbulent society, which has embraced fast-paced, fast-food images, is this need for a stronger image depth really a reflection of the need for more *inner* depth?

Image depth has been the object of my work since I began making computer art in 1965 at Carnegie-Mellon University. This goal was functioning on an intuitive level in those days, and I've just recently been able to define it consciously. It required more "inner depth" to reach this point.

Carnegie-Mellon University

Carnegie-Mellon University is a small private university with approximately 5,000 students. It has two excellent, but separate, colleges that stand in stark contrast to each other: the College of Fine Arts and the College of Engineering and Science. Nowadays the cooperation between the colleges is much better, but when I went there they had little to do with each other. There was so little interaction between the two colleges that even the freshmen didn't intermingle academically. To me this historical separation represents the art/science dichotomy that I found discomfiting at the time, and still do today. After spending three years pursuing a degree in mathematics in the College of Engineering, I decided to switch to the College of Fine Arts and pursue a degree in art. This meant that I had to start all over as a freshman again. It seemed a bizarre move to make at the time, but I had several reasons for my decision:

(1) I had a strong need to do something creative and expressive. I perceived mathematics to be such a closed field that I thought I would never reach a point where I could do creative work. There was just too much I needed to learn before I could get started. Besides, I felt rather restrained by the thinking processes involved. I could not find a place where my imagination could soar.

(2) Although I had been drawing fairly consistently since I was a small child, I had really just discovered art, and I was very excited about it! Originally, I had gone into mathematics because I was good at it, not because I was in love with it. Now, with art, I envisioned myself as having the opportunity to experience reality with more of myself than just my intellect. In drawing objects and people, I endeavored to *feel* as well as think about them. I wanted to strive for a more holistic perception of reality, not just accumulate abstract ideas about it.

(3) Most important, I felt that this was the right thing to do *on an intuitive level.* As I look back upon my life, I see that my intuitive decisions turned out to be the best ones I made. I still regret the bad decisions that I based strictly on logic, ignoring the fact that intuition told me to do otherwise. What this suggests is that there is a powerful subconscious part of the mind that knows more about what is best for us than our conscious mind does. It does not present information to us in a cold, linear, logical manner, but usually provides us with nebulous feelings of correctness or incorrectness about matters. If we are fortunate, it may even find more definite paths to convey information. It is difficult for the empiricist to accept this thinking process as legitimate.

I did not abandon the pursuit of my math degree for the sake of the new adventure in art. I had gone too far in that direction to let it slip away. Instead, I petitioned the College of Engineering and received permission to get my math degree even though I was no longer part of that college, and I fulfilled all the requirements.

As a freshman art student, I made the discovery that there was a general-purpose computer on campus that was available to anyone who wanted to use it. I decided to see if I could explore new art forms with this new tool. Since the computer was set up to be used for engineering purposes, the only input/output devices available at the time were punched cards and line-printers. Unlike traditional forms of the artistic process, in which there is a very small time lapse between making an aesthetic decision and seeing the results of that decision, interaction with this machine involved a wait of several hours between submitting a "job" to be run and receiving an output on printer paper. In adapting the machine to conventional artistic methods, I programmed the computer to print my "drawings" with overlaid print characters, and clustered my aesthetic decisions in order to get as much as possible from the long interval between decision and feedback.

I learned that I could overprint each line of characters with a different line of characters and get a crude form of grey-scale tonality. The computer, failing to advance the paper as expected, made the line-printer appear to be broken; this drove computer operators crazy, until they got used to seeing my jobs come through. I also discovered that through mathematical techniques combined with random number generation, I could create an attitude in my computer art similar to that in my paintings. When painting, I used images from my subconscious to make the pictures interesting. I was similarly entertained by the variety of images generated by my computer programs, which carefully balanced chaotic random choice with rules of pictorial composition that I invented. However, my reaction to the results of these diverse

activities was that my paintings felt very personal to me and my computer art felt very *detached.* Thus I began my efforts toward resolving the differences between the two.

Another discovery was that I learned to program better when I had a larger purpose than doing general problem-solving tasks; and that purpose was to make art. I did rather ordinary work in my first programming classes as a math major; I lacked motivation. Later, in contrast, I began inventing all sorts of programming concepts to help me make my art. I try to convey this expanded sense of purpose to my students in the programming classes I now teach.

I also found that programming is an absorbing, mind-intensive activity; throughout my entire programming career I have always had to remind myself to stay aware of the purposes for my involvement in it. It's easy to get engrossed in coding general problem-solving tasks and forget to make art. Computers are so enticing that it's easy just to play with them for hours and hours.

In other words, after this initial period in which I used art as a catalyst to begin programming, I had to make an effort to prevent the programming from becoming an end in itself—to be sure that art continued to be the catalyst. Although I receive more external rewards for programming, the internal rewards for art are more fulfilling. However, because of social and professional influences, it is easy to let the "outer" dominate the "inner"— and to feel empty inside as a result. I have learned, through the years, to give more and more attention to the "inner."

I gained a lot of respect for the naive programmer. Naive programmers make lots of programming errors that turn into interesting, unanticipated visual results. (It is harder to generate these unexpected gifts after you have programmed for awhile; now that I have lost my programming naivete, I have to rely on very complex programs and very involved interactions between different sections of code to produce similar effects.) I also learned how to make programs extremely versatile and malleable, so that I could take many paths through the same program and achieve different results. One path was for the task that I originally set out to do, and the others were for the mistakes that I exploited and turned into something usable. It is not easy to program this way.

It became evident to me that creativity was not confined to the domain of painting but could occur in programming as well, and I was now using mathematics in a very plastic, creative way. I began to see programming as a form of personal expression, and I began to enjoy working with other people's programs to see what their personalities were like. I do not mean

that because programming became more personal the images I created also became personal. The mind, the code, and the image are separate in a way that inhibits the artistic process. I was getting involved with the intellect in a personal, rewarding fashion, but the intellect was still interfering with the subconscious. It has to get out of the way for the mind to form images in a totally rewarding manner.

At C.M.U. I was very fortunate to have Herbert Simon as my advisor. He is an outstanding computer scientist who loves to encourage expansion of computers into other fields. Under his guidance, I had many ideas and produced an amazing amount of work. In particular, he kept people off my back who had no idea in the world what I was doing and saw no reason why I should be allowed to continue doing it. Several interesting debates arose because nobody was ever sure how much creativity was the machine's and how much was mine. I was not part of the debates, but I would have argued for myself, whereas others saw significant strains of artificial intelligence in the work I was doing and felt that it played a larger role in creating the work than I felt it did. The computers threw the images at me, but I chose the images I liked and changed the program to make more of those images—it was all a matter of probabilities. I also wrote all the algorithms that produced the shapes in the first place, and I put aesthetics into the algorithms.

In contrast, in my traditional painting I did not consciously "write the programs" that generated the images. However, as with my computer artwork, I also had to choose and mold the images that surfaced in my mind. I say I didn't consciously write the programs because I believe it is possible that the material in the subconscious mind is programmed by actions and events that precede what our memory can recall.

In my last year or so at C.M.U., around 1967, I wrote a program that drew vector images on a cathode-ray tube in a dark room. The program generated a six-minute sequence of visual images that were different each time I ran the program. This meant that the rules I programmed for still-frame composition had to be extended to organize sequences of images and to keep their tempo interesting; in particular, the beginning and ending sequences had to feel right. Dr. Simon pointed out that I had moved into the domain of music for this piece. Incidentally, working in the darkened room allowed me to extend the life of my images beyond the persistence of the cathode-ray tube phospher, with the ghosts of previous images adding depth and continuity to the piece. It was very difficult capturing that quality on film.

After spending six-and-a-half years at C.M.U., I went to work at the new Computer Graphics Department at the University of Utah. I found myself thrust into a world of polygons and hidden-surface algorithms. I could no longer be an artist doing programming, I had to be a "computer scientist" doing programming. I was now programming for other people, not just for myself, and I had to become "professional." No longer was I allowed to have nebulous programming goals and allow accidents and interaction to dictate the program's developmental direction. I had to organize myself toward specific goals and move as efficiently as possible toward those goals, writing clean, maintainable code in the process. My naive-programmer days were over.

The shift in processes can be compared to the difference between Rembrandt's painting and Cezanne's painting. Because of the inflexibility of the glazing medium, Rembrandt had to plan his paintings completely before executing them. Cezanne could allow his painting to grow and suggest new ideas as he went along, and the final painting would be different from the initial concept.

The graduate students at the University of Utah had conceived ingenious ways to describe objects in terms of intersecting flat planes in space, and they worked very hard to render them as realistically as possible. (These objects were usually airplanes and tanks, since the military was paying for this endeavor.) Ironically, most of their attempts at realism came out looking surrealistic, and the computer scientists were then forced to deal with this unexpected tendency of the medium.

For the life of me, I couldn't figure how to render in polygonal form the biomorphic forms that I was making in my painting. I felt that it was my job to fit into this environment and have my art contribute to what they were doing, but I couldn't see how to do it and maintain my artistic integrity. Since the man I worked for was an M.I.T.-trained pure empiricist and since there was so much pressure to conform to this mode of thinking, I decided to divide my time strictly so that I did systems programming by day and painting by night. As external motivation for my painting, I worked toward my M.F.A. from the university's Art Department. The computer scientists wanted pure empiricism, so I gave them pure empiricism; but at night my painting lacked anything remotely resembling empiricism.

Carrying on such diverse functions so intensely and separately, I actually experienced the feeling of switching between the two brain hemispheres.

52 One day after I finished programming for the day and began painting, I said to myself: "Gee, it feels like I have two brains!" *I had no reference for the experience.* Many years later, when I read Betty Edwards's book *Drawing on the Right Side of the Brain,* I became so excited about the dual-brain concept that I started writing papers about its relationship to computer graphics. However, by the time I started doing that, the fad had already passed and other people were bored with it.

Although I may seem anti-empiricist, I believe that empiricism is a very important tool for discrimination and for learning the rules of cause and effect. However, I rebel when this tool is worshipped as the only way to experience reality and is allowed to restrict rather than enrich our lives. (On the other hand, I become equally rebellious when I see artists using computer graphics as an opportunity to exert control over the technician— a trend that seems to be growing. Gaining control over that which one fears shouldn't involve power plays that attempt to convert other people into tools.)

A Utah graduate student once told me about his attempts at learning to draw. While drawing a stationary physical object, he became aware that he was visually receiving two contradictory views of the object, a different one with each eye. Since both views seemed equally good, he found that he could not choose between the two and chose instead to abandon his attempts at drawing. This is a good example of how restricting yourself to one approach can prevent you from having greater visual experiences.

In computer graphics, this problem has grown into a self-restricting, self-perpetuating paradigm. At each major conference the participants expect better and better renderings of clouds, trees, fire, or whatever object they feel is the most difficult to render at the current stage of technological development. They fail to see that art does not get better each year. It certainly changes, but it does not necessarily improve. The only time that art is seen in developmental stages is when society maps such patterns onto its history. Using oil paints instead of tempera allowed artists to achieve more three-dimensional depth during the early Renaissance, but this did not necessarily make the art better. It only gave the artist another option; it was a technological innovation, not an artistic one. Technology should *give* freedom to the artistic process, not restrict it. Painting did not stop when photography came along. It changed. Computer graphics must do the same. It is still being defined by other media, which, in turn, are being defined by commercial concerns—unfortunately.

Regarding computer graphics images, the question arises whether or not we should even be considering the work of computer graphics designers

as art, when those who make it often don't intend it to be art? It is often intended to be a clever way to solve interesting technical problems and get paid for it as well. Computer graphicists are basically problem solvers who are thrilled with the notion that they are not limited to just writing about and talking about their solutions to the problems, but can show them off visually too. Whereas artists get pleasure from implementing a holistic conception in visual space, computer graphicists get pleasure from translating a holistic algorithmic idea into linear, logical steps for transmission to and use by their colleagues. They do not seem disturbed by the lack of holistic content in the pictures their algorithm makes. The fact that it matches literal visual reality to some degree is good enough. The holistic experience is the key. As an artist I prefer the holistic experience that is closer to the visual image, without the separation imposed by the computer.

Computer Painting

The realization of a more holistic computer-graphics experience came closer with the invention of the frame-buffer around 1974–75. Computer memory is just a set of discrete locations that hold numbers, and these numbers can represent anything—letters of the alphabet, instructions to the computer, various kinds of fish, etc. The frame-buffer organizes these memory locations into a two-dimensional format that resembles the shape of a TV screen, and each memory location represents a spot of a particular intensity or color on that screen. This simple idea revolutionized computer graphics. Accompanied by other electronic devices like an electronic pen and tablet for input, the computer could finally simulate the interactive painting process.

Working with two paint systems that utilized the frame-buffer—one called Crayon, written by Jim Blinn, and another I had written myself—I created a group of surrealistic computer paintings. With my program, I tried to incorporate chance effects into the brush. I didn't get much reaction to my surrealistic efforts, so I decided to switch modes and do a traditional self-portrait. Utah's art scene consists mostly of portraits and landscapes, so I figured I'd really fit in. I set up my mirror next to the computer and made a representational image of myself. However, my art history training did me in: I allowed some of Cezanne's color planes to sneak into the painting. "Duane, that's the best thing you've ever done! But why the orange and blue patches?" I scurried back to my weird surrealistic work; there was simply no pleasing these guys. (Actually, a superb photograph by Mike Milochek

of me painting my self-portrait gave me more attention than I received from any work *I* did. It became a symbol of the emerging computer-painting process.)

I never really continued computer painting beyond this period, although it offers many benefits: speed of execution, ease of mixing and changing colors, the ability to apply various mathematical functions to the image, the ability to scan in and modify other images, the ability to develop the same image along many different lines, relying on accurate image storage and retrieval techniques. (In fact, all these capabilities sometimes overwhelm beginning students and all they do is explore capabilities, instead of making art.)

I do find computer painting satisfying in certain ways. Since paint systems emulate the traditional painting process so well, I find no difficulty in doing my "subconscious painting" with them. The increased speed of working interests me only when it helps my artistic process; it has more importance in commercial endeavors. The mathematical functions work for me as long as their results are integrated with my image and don't stand out as "computer art tricks." The problem occurs when I try to make the result into an art object. I have a need to feel the surface of art objects, and the particular surface and size of the TV set has no significant personal relevance to me. Moving it to another medium like film, photography, or printmaking changes something that was relevant to the image—color, light, size, resolution.

I'm looking for more out of this medium than the simulation of an already-existing medium. I see the paint system as representing the engineer's concept of what he *thinks* the artist needs. Even though it did emerge so naturally from the invention of the frame-buffer, I can only accept it as a stepping stone toward something better. I also see painting on TV sets as being symbolic of the fleeting superficiality of today's visual images—in the commercial world, on television, and in art galleries. Like the technological process in general, each new "development" grabs immediate attention but is quickly replaced by a better, more interesting image. I see the true art object as a work that has enough depth to allow the viewer to get more and more from it over long periods of time. Computer graphics may not be the proper medium to give depth to the art object; too much of its content is governed by mathematics.

Rejecting the "fast food" approach, I continued my search to find a unique essence in this medium. I moved to the suburbs of New York and began working at the computer graphics laboratory at the New York Institute of Technology.

The computer graphics lab at N.Y.I.T. was formed around 1974 to design computer systems to improve the two-dimensional conventional animation process. N.Y.I.T. had just completed a full-length animated cartoon called *Tubby the Tuba,* using the laborious traditional process. Since the film had taken four years to complete (much longer than anticipated), the Institute began looking for more efficient methods of making animation. Paint systems work well as a means to paint animation backgrounds, and the "filling algorithm" (inherent in any good paint system) works especially well for painting animation cels. Ed Catmull, director of the lab, designed a vector-based in-betweening system that reduced time by automatically generating cels that fit between key hand-drawn frames. This was exciting research, and it was all interesting to me. However, since it was not relevant to the artistic ideas that I was wrestling with at the time, I postponed my immediate involvement with this activity. I was more interested in putting the three-dimensional tools developed at University of Utah into some personal aesthetic context. And, even though the researchers at the lab here were enmeshed in 2-D processes, they knew that 3-D computer animation was imminent and appreciated the introduction of these redesigned Utah tools into their environment.

In the artworks I began to produce at N.Y.I.T., some of which are featured in this essay, I accepted standard concepts of object-oriented computer graphics as my basis—e.g., solids of revolution, polygon tilers, B-spline patches, and polygonal databases. Using these programming concepts, I proceeded to design and build examples of these tools with particular orientation toward my artistic sensibilities. For example, I accepted the notion that programming accidents and complex interaction sometimes contribute to interesting visual effects that may relate to my aesthetic. I try always to be open to creative associations. I then use the computer to build imagery based upon ephemeral poetic and mathematical concepts and upon my own psychic sense, which I described as surrealistic in its patterns of free association. Allowing mathematical/programming ideas to merge with visual ones, I attempt to find a unique form of personal expression—an expression controlled and sometimes hampered by my initial premise of starting with traditional computer graphics tools. Because of the nature of these tools, the final work still reflects a stiff, object-oriented space with mathematically calculated light sources, shading, and perspective. However, the design of the original computer graphic tools is strong and it is hard to resist using them as a starting point. It is much

harder to design personal tools of equivalent strength completely on my own.

I refer the reader who is unfamiliar with general computer graphics tools to Andrew Glassner's book *Computer Graphics User's Guide,* which is oriented toward the artist as user. It is very useful for learning technical concepts without getting into the mathematics involved. I use it as a text in some of my classes.

In thinking about three-dimensional computer graphics, one must deal with two related spaces: the two-dimensional visual space in which the work is seen, and the multidimensional mathematical space containing the numeric information and algorithmic schemes that generate the work. The visual space, being projected from the mathematical space, can be thought of as a certain way of looking at the latter space. The rendering technique involved takes a snapshot from one point of view of a complicated space that really has many points of view. This relationship of spaces is similar to the esoteric idea that our own view of experiential reality is being projected for us by a more fundamental and more complete "greater reality"; and, as our consciousness grows, we are likely to experience more of the "greater reality" and develop greater understanding of how the lesser realities are projected from it and by it. Hence, in greater realization, we are able to free ourselves from individual life patterns.

Likewise, in computer graphics, the more we understand the mathematical reality behind the images, the more we are able to understand the projection of the individual images and to see them in a different light. Our added awareness frees us from old patterns of thinking about images. Similarly, once we see how software systems logically work, we can free ourselves from clinging to one or another of them. Instead of jumping around the branches of a tree trying to familiarize ourselves with each new branch, we should ground ourselves in the roots and see where the branches come from.

The artwork following page 68 has aesthetic considerations that include more than "meets the eye." Although it can be appreciated on that level alone, it also has a "greater reality." Discovering this reality is like understanding the formal logical organization of Rembrandt's *Polish Rider* or the symbolic meaning in Robert Campin's masterpiece *The Annunciation.* Except for its mathematical basis, this method of relating an artwork to its "greater reality" is merely an extension of what artists, art historians, and art lovers normally do with works of art.

Technical Details Related to Eggs

As in nature, my three-dimensional computer artwork has its evolutionary roots in the "egg." Various parts of *Space Carrots* (see Plate 1) are "mathe-

matical eggs'' formed by using the concept of "solid of revolution." A solid of revolution is formed by taking a flat, 2-D shape or curve and rotating it about an axis to form a 3-D figure. If one used a question-mark-like curve, the resulting figure would look like a light bulb.

The concept used in *Space Carrots* was that of a vector forming the radius of a circle in the "XZ" mathematical plane, growing larger as it moves downward in the "Y" direction toward the center of the form, and then growing gradually smaller again toward the bottom, to form an egg. The varying radius, using the vertical egg-like curve to determine its length, changes as it lofts circles in the XZ plane. In mathematical space, the circles themselves are really nothing but (x,y,z) point calculations that are deposited equidistant from each other at the edge of the radius, which spins in a circular path. Looked at from the top down, each set of equidistant points vaguely resembles a circle. To give the egg visual substance, I used the calculated points to attach B-spline patches to the etheric form, much as a roofer would use nails to attach shingles to a curved house.[2]

Even though the use of patches to achieve such simple "egg-carrots" may seem to be overkill to the technically sophisticated reader, they are indispensable for generating the green, amorphous forms in *Space Carrots.* These forms are the result of adding some restrained random numbers to the radius lengths that form the egg.

Although I could generate a wide variety of interesting forms by varying my egg radii randomly, I decided to utilize solids of revolution for more controlled sculpting effects. However, instead of using multiple curves to define the object, I used a table-lookup technique similar to that used in texture mapping and bump mapping.[3] In a frame-buffer other than the rendering buffer, I drew an unusual picture of my face using conventional paint system techniques (see Plate 2). The drawing's uniqueness comes from the fact that I visualized it as a soup-can label wrapped around an egg. I imagined my head as an egg with shades of light and dark representing the spatial differences between my head and the egg. In the "null" case, if I had presented to my rendering algorithm a totally gray drawing in place of *Face,* it would have sculpted faceless Humpty Dumpty.

In generating the egg, each time the radius required a new length, instead of adding some random number to it the program would add a number from the frame-buffer that contained the face drawing. If the number showed white in the "face drawing" buffer, the radius would move out the farthest, and if the number showed black, the radius would shrink toward the center of the egg.[4] As you can see (*Egghead,* Plate 3), the experiment was not as successful as I had hoped. It resembles what I look like in someone else's reality projection but not what I look like in my own! Actually, the problems I

encountered with this experiment stem from two sources: my preconditioning as an artist in seeing light and shadows in figure drawing, and the grossness of the tools I'd developed to do the task. This taught me not to get caught up in the above-mentioned "realistic rendering" paradigm!

Notice that I incorporated the Z-buffer into the lower half of the picture as part of the image. A Z-buffer is an extra frame-buffer or two used to hold the picture's depth information in order to allow a programming mechanism to resolve depth overlap and intersection on a pixel-by-pixel basis. This mechanism determines how much of the image gets projected from the multi-dimensional "greater reality" to the two-dimensional frame-buffer space.[5] Actually, exotic uses of the Z-buffer add another chance component to the process. Since I love to incorporate chance factors into my artwork, I use the Z-buffer extensively, either visibly or behind the scenes.

Warm-Cool One (Plate 4) is an example of my "behind-the-scenes" use of a Z-buffer. This picture was created by using both the finished two-dimensional frame-buffer image of *Space Carrots* and its saved Z-buffer. On a pixel-by-pixel basis, I used the following procedure to modify the image: (1) I separated the pixel's color component from its intensity component. Using an eight-bit pixel, I defined the intensity to be the lower five bits and the color to be the upper three bits. I had eight different colors to work with and thirty-two different intensities for each color. (2) I then chose the pixel's associated Z-buffer value from the same pixel position in the saved Z-buffer. (3) Using this value as an index for a red/green peppermint scheme which I had mapped onto "Z depth," I accordingly changed the pixel's color value. (4) Finally, keeping the old intensity with the new color, I put the new pixel into the old pixel's frame-buffer position.

This scheme actually started out as an attempt to use artistic warm/cool space to exaggerate depth cues—a trick that makes a two-dimensional picture look more three-dimensional. Later pictures along this line were more successful but were less visually interesting than this one. In my work, I have the general attitude that the visual image takes precedence over the concept behind it.

The Figure Series

Two of the most powerful tools designed for three-dimensional computer graphics are the polygon tiler (or polygon renderer) and the three-dimensional points-polygon database. In the "greater reality," the points-polygon database contains numeric information on how to render a particular complex form, and the polygon tiler understands this format and renders a view of the form in the visual frame-buffer space.

I developed the polygon tiler used in the next set of works to reflect my own aesthetic interests. I actually tried it for the first time in *Space Carrots.* Note, in *Space Carrots,* the randomly formed beam-like object that intersects the space. The sides of the beam, with accompanying aliasing artifacts, were rendered by the tiler.

In *Figure with Aura and Guards* (Plate 5), three apparent instances, or views, of a female figure were defined as a points-polygon database and rendered using my polygon tiler. I say "apparent instances" because the central form in the picture is actually composed of several exploded instances of the figure that are overlayed with various degrees of transparency. The form explosion occurs along the vector direction of the polygon normals, calculated at each vertex of polygonal intersection. In this case, each "normal vector" at a particular vertex is the sum of vectors perpendicular to the surface of every polygon that intersects at that vertex.[6] If the normals were rendered along with the polygons, the figure would look like a porcupine. However, the normals are like ghosts in that they are not rendered from the "greater reality" into the preceived reality, but may affect it nonetheless.

In another behind-the-scenes maneuver, I included the egg concept as part of the greater reality of *Figure with Aura and Guards.* The texture on the surface of the figures is a reflection of the egg's presence. The egg, in this case, is a sphere with infinite radius whose center is the center of the female database. Instances of the picture's Z-buffer are randomly placed on the surface of this sphere as part of the following algorithm: rays from the figure emanate along the normal vectors away from the figure and toward the sphere's surface; they retrieve Z-buffer patterns and colors and replace them on the surface of the figure.

Thus we have a dance that is an interaction between the Z-buffer mapped on the surface of the invisible egg and the figure being rendered at the egg's center. A change in one affects the other. As in a dance of subatomic particles, complex time-space interactions occur that make events appear unpredictable.

In addition, the figure's dance with the egg is symbolized by her auric emanations toward the egg. In fact, the central figure turned out to be so delicate that I just had to put two guards in the picture to protect her.

The remaining pictures in this series were produced by the same algorithmic mechanisms used in the previous ones, and all contain the dance with the egg. *Sparkling Giacometti Sequence* (Plate 6) reflects the use of the "augmented" transparency mode of my polygon tiler. The augmented transparency mode renders transparent polygons with sparkles at the edges of the polygons. The sparkles really are the result of a bug, or programming

mistake, that occurred during the implementation of the transparency feature. Here is a case where a mistake in the code became a feature of the program; I worked around it to complete the tiler's transparency option.

Sparkling Giacometti Sequence, Tall Movement (Plate 7), *Stretched Movement* (Plate 8), and *Stretched Movement Zoomed* (Plate 9) are products of a certain spatial tension programmed into their greater reality. This spatial tension causes distortions to copies of the figure that are placed in a spatial line with each other. The distortion occurs along the direction of the normal component which is in line with the other figures. However, the end figures remain unaffected when rendered. The distortion also varies from figure to figure, based upon where a figure is placed relative to the others.

Picasso Two (Plate 10) is the pinnacle of this series. It is the product of the complex interaction of every element mentioned so far. In this work, the effects created by chance, grouped with those created by unpredictably complex algorithmic interaction, form a visual tension when played against the solid definition of the figure. This tension in visual space is similar to that which I find in many of Picasso's paintings.

Space Forms

Spatial tension is also an integral component of the next series I attempted—a series much different from the previous one. In these new images I attempted to create a form-generating space that resembles, in a sense, our own real, star-filled "outer" space. This visual space also has stars in it; they exert gravitational forces on objects that enter the space. However, that's where the similarities end. The visual space differs from outer space in that these stars have no mass and their interacting gravitational forces create only visual forms. *Space One* (Plate 13) is a six-by-six matrix of star spaces with their associated blobby forms. *Tex Blob* (Plate 14) is one of those space blobs with patterns texture-mapped onto its surface. And *Warm-Cool One Dipped into Gravity Space* (Plate 15) is *Warm-Cool One* (Plate 4) distorted by the space forces that create the blobs. Finally, *Folded Space* (Plate 16)—a freer, more complex version—is composed of overlapping spaces that create blobby forms that ripple away from their centers.

Earlier, I mentioned the need to create more space-oriented computer graphics tools for more holistic methods of design. In a sense, this last series involves a primitive attempt to do just that. Please do not infer that the visual spaces should resemble our cosmic space—that was simply part of its artistic implementation. Rather, the merit of its artistic-tool design lies in its facility for designing a visual space, that, in turn, controls the design and

placement of objects within it. This reverses the usual method of spatial design, in which objects are arbitrarily placed together. Philosophically, the objects in the greater reality are much more related than our senses normally lead us to believe. My artwork attempts to suggest that relationship. I would prefer general artistic tools that do the same.

For my next work I chose a medium more flexible for realizing psyche/art involvement with less emphasis on mathematics. I used traditional animation techniques with a computer production base. This twenty-two-minute piece, *Living above the Mouse's Ear,* reveals psychic permutations that create their own dreamlike spaces—more typical of my conventional painting concerns.

In this work I continued the use of ephemeral, metamorphic space, with the Taoist sense of change itself being more important than static states of reality. From subconsciously derived images emerges a personal mythology that, I hope, can provide information for greater individual growth for both myself and the viewer. Reflecting on Joseph Campbell's idea that "Myths are public dreams; dreams are private myths,"[7] I used this piece to try to relate my private unconscious to the public collective unconscious. The challenge is to interpret a private, dreamlike image correctly and mold it into a form to which others can relate. Even if they have difficulty understanding it, becoming synchronous with it should allow them to relate to it on an unconscious level. The trick is to loosen up and allow it to happen.

Making computer art through the design and/or modification of programming tools requires great amounts of time and energy. Just to develop the programming proficiency necessary to work this way, I passed up the opportunity to make a lot of conventional art. However, programming by day and painting by night continues to give a pleasant balance to my life. To reinforce an earlier theme, it even gives me a means of making a living without compromising my art.

Conclusions

Even though visual ideas are holistically conceived, in order to realize these ideas in the computer medium I must go through the intellect. In other words, for strong content to emerge, the artistic ideas must be executed with the least amount of translation into linear, sequential, tool-operating commands. If the tools are so dominant that a smooth, effortless dialogue cannot occur between "art thought" and "artwork," the artist must either (1) conceive the work totally beforehand and use the tools to execute it, or (2) work in feedback

chunks, so that the changes in design imposed by the linear mathematical tools feed back into new ideas that get translated yet again into linear commands. The "idea first, work second" technique is effective, but it demands that the artist assume two roles: the thinker who has the idea and the technician who executes it. The "chunk" style admits the difference between what the artist conceives and what the tools can produce, and, although the results are often interesting, this is the least likely state through which strong personal content can emerge.

The inherent potential in mathematics to produce quickly and easily regular 3-D forms and to duplicate them is a positive factor as long as the interface to these tools doesn't force the artist (while making art) to think as the technician thinks. But how do we build complex free-form structures from these mathematical modular elements without thinking in a linear sequence of commands? One solution is to tie the interface to continuous body movements that we rarely think about—as in the act of drawing. Just as in learning to draw, it takes time for the artist to become practiced in these movements and stop thinking about them consciously. Various input devices have to be explored and the end result may make the artist look like a dancer or a Tai-Chi expert; but smooth, continuous movements are more conducive to the art-making process than are discrete menu-selection or keyboard-poking actions.

To make the interface even more workable, the tools should be adjusted to the drawing style of each individual artist. This, in turn, requires the artist to become an integral part of the tool-designing stage at the interface level, and, again, to be both artist and technician—but there will be fewer technical concerns during the art-making stage later on. Although the artist, during the tool-making phase, has to work in a linear, sequential manner for a time, this will encourage the development of mental discipline and concentration. Eventually, if he gets ambitious enough to take his newly formed skills into other areas of the 3-D system, he may find that the effects he is now getting are better tuned to the artistic process than those he had before. Then mathematics can dominate only if the artist wishes it, and more free-form structures can emerge. Once this happens, considering the added artistic dimensions possible in 3-D computer graphics, the artist may even achieve greater depth than through conventional processes. It is harder to be more immediate and spontaneous than with drawing, but what we are ideally talking about is drawing in three dimensions with color.

There are some difficult problems involved in this computer graphics interface idea—what input devices to use and how to map command strings to strokes. I have presented here just one possible solution. The bottom line

is that the design approach should come from the artistic side of the technician, not from the technical side of the artist.

In summary, computer programming and making art involve two very different mental processes that are brought together in computer graphics. Computer graphics is typically separated into two parts: (1) the making of computer tools that create visual effects, and (2) the use of these tools to make art. These two parts represent the traditional roles of the computer programmer as the tool builder and the artist as the tool user. The programmer makes tools similar to that which artists have seen in the past, and the artist hopes for tools similar to that which he has known in the past. In this way the programmer can maintain a superficial understanding of art concepts, and the artist can minimize retraining himself technically and can concentrate on putting qualities into the artwork that give it depth—qualities that perhaps reflect the human condition or reflect part of the artist's subconscious mind that touches us all. This is the way computer paint systems are developed.

However, computer graphics can also be a combination of both art and science into a uniform discipline without the tool/user separation. Individuals with the talent and fortitude to become both an artist and a programmer now have the unique opportunity to explore the combination of two diverse mental processes in the same discipline. Unfortunately, however, at the present state of computer programming technology, the artist-programmer must relinquish some control of the artwork to mathematical processes that create uniform forms. Hence, the artistic depth of the piece suffers at the expense of clever, but artistically superficial, mathematical image-making. This may suffice for commercial television, but not for sustaining qualities in artwork intended to enrich one's life.

If there is an answer to this problem, it rests in the hands of individuals who are both artists and programmers. Artist-programmers must move one level deeper into the technology and create better visually oriented programming languages so that sophisticated artistic concepts can be expressed by the artist-programmer, without giving up control to mathematics. Another beneficiary will be the nonprogramming artist, who will have better tools to make art.

Notes

1. Eugen Herrigel, *Zen in the Art of Archery* (New York: Vintage Books, 1953), 46.

64

2. Andrew S. Glassner, *Computer Graphics User's Guide* (Indianapolis: Howard W. Sams & Co., 1984), 130.

3. Ibid., 101–4.

4. Ibid., 161.

5. Ibid., 169.

6. Ibid., 68.

7. Joseph Campbell, *Myths To Live By* (Toronto: Bantam Books, 1972), 12.

References

Arguelles, Jose A. *The Transformative Vision (Reflections on the Nature and History of Human Expression)*. Boulder: Shambhala, 1975.

Edwards, Betty. *Drawing on the Right Side of the Brain*. Los Angeles: J. P. Tarcher, 1979.

Evans-Wentz, W. Y. *The Tibetan Book of the Dead*. London: Oxford University Press, 1960.

Glassner, Andrew S. *Computer Graphics User's Guide*. Indianapolis: Howard W. Sams & Co., 1984.

Herrigel, Eugen. *Zen in the Art of Archery*. New York: Vintage Books, 1953.

Langer, Susanne K. *Philosophy in a New Key: A Study in the Symbolism of Reason, Rite, and Art*. Cambridge: Harvard University Press, 1942.

Palyka, Duane M. "Computer/Art—Depolarization and Unification." *IEEE Computer Graphics and Applications* 5, no. 7 (July 1985): 46–56.

Sachter, Judy E. "The Basic Concepts of Three-Dimensional Computer Graphics for Artists." Master's thesis, Ohio State University, 1984.

Thirty Years of Searching:

Shifting Vantage Points

SONIA LANDY SHERIDAN

All around the world one can feel the pressure to employ the most recent communication systems. In art and education, which lag years behind the sciences, one can sense the urgency to catch up. In 1985 I was a living exhibition for two months in the show *Electra* at the Musée d'Art Moderne de la Ville de Paris. The exhibition was a history of the use of electricity in modern art. Because it was very popular with all sectors of the public, I was later invited by the French Ministry of Culture to return to Paris to consult on the use of new technology in art education. From Paris I went to Madrid, where for three weeks I participated in another living exhibition at the new Centro de Arte Reine Sofía in a show entitled *Procesos: Cultura y Nuevas Tecnologías,* which, like *Electra,* provided the Spanish population with an opportunity to interact with artists using the latest communications technology. How did it happen that a woman six decades old is working with state-of-the-art technology and finds herself in worldwide demand?

Certainly I had no idea, three decades ago, where my artistic travels would take me, nor how difficult a road it would be—and it was a constant struggle all the way. What I did know, or believe, was that art was a process of searching, and in the process new territory would be discovered; new ideas, new perceptions, and new awarenesses would emerge. But it was only after arriving at critical vantage points—usually once in each decade, with minor vantage points every five years—that I could look back and see with bright clarity what had before been only a haze. As I saw the territory I had worked my way through at each stage, I would begin to perceive what I had only been dimly aware of before.

I saw with heightened vision how developments in the application and reapplication of energy led to the creation of tools that provide us with the means for voyaging through time and space.

65

I saw how we moved through time and space with these tools—from manual to mechanical, to electronic, photronic, and biologic processes—at each stage altering our perceptions of time and space.

I saw that as we altered our perceptions of time and space, we altered our perceptions of objects in space, then of objects in time, until we arrived at a point where we were able to visualize the "shape of time." I saw that we could stop time to observe it. We could move with time and visualize it.

But first, in order to arrive at a point where I could visualize time not only in dreams, but in the cold light of technology, I needed a context, a vehicle for voyaging. Into this vehicle I would take my personal tools—a positive attitude toward art and science as historical bodies of knowledge worthy of attention, and a philosophy filled with notions of totality, the dialectics of nature, the unity of opposites, and Western and Eastern educational experiences.

After years as a university student in New York City, and more years as a teacher in California and Taiwan schools, I found myself training teachers at the California College of Arts and Crafts. From there I moved on to teaching art at the School of the Art Institute of Chicago. About twenty-three years ago I decided that the art school would remain my context, but that I would be an artist/teacher rather than a teacher/artist. The art school became the vehicle for my voyage. During the nearly two decades that I worked at the Art Institute of Chicago, before my early retirement in 1980, I tried to synchronize my art and teaching with historical events as I understood them from my particular context, which was insular yet free enough to permit a good deal of motion and change.

As artist I gradually educated myself through my work and teaching. As educator I constantly examined the relationship of the art to the society. Each decade flowed into the next in harmony, but each was unique. The pictures I am going to discuss (some of which appear on the following pages, some in the color plate section) are representative of the 1950s, 1960s, 1970s, and 1980s. They trace the transformations in my art and teaching, especially the development of the Generative Systems program in the 1970s and my work with tools created by some of my M.F.A. students in the 1980s. They include slides from *Electra* in Paris and my recent work *Wall Notes*.

Compare the 1947 lithograph *The Fire* (Figure 1), which shows me shaking down the ashes of a University of Illinois Quonset hut stove, with the 1985 computer graphic *Looking through the Time Plane* (Plate 18). The earlier image was made when I was a twenty-three-year-old student, with all the physical energy and vitality of youth. I admired Daumier, Käthe Kollwitz, Rembrandt, Goya, and Michelangelo. Emotionally charged art that "cried of the human condition" was the highest form of art to my youthful mind. I

Fig. 1. *The Fire.*
Lithograph. 1947.

knew about "abstract" art, and about the Bauhaus, but I thought expression-
ism was the greatest art. Almost forty years later, I have moved from sheer
physical energy to mental projection, as shown in the 1985 computer-
generated portrait. Thirty years of teaching and creating have moved me
along a path in synchronicity with the society, from a mechanical gear-driven
era to an electronic, flowing era. The new does not negate the old; it simply
alters it.

I started my first professional teaching in the 1950s, when the Prisma-
color drawing *Students* (Figure 2) was made. It is satirical and critical in the
vein of expressionism, but in a style that was a little influenced by William
Gropper, whom I admired at that time, although not nearly as much as
Daumier and Kollwitz. It is indicative of how I tried to meld American and
European ideas as early as the 1950s. The 1957 photo of my high school
students, *Operation Rat Team* (Figure 3), was a joint effort of John Urton
(one-time Juilliard opera student and Ph.D.-candidate-in-philosophy-turned-
biology-teacher) and myself. For this project I provided training in medical
illustration. Combining scientific research and art was typical of the many
interactive group projects I initiated or participated in from the beginning of
my teaching career. The project was a precursor of the Generative Systems
program, which I set up exactly thirteen years later, in 1970.

In 1957 I abruptly changed my context when I accompanied my student
husband to Taiwan. The conte crayon drawing *Taiwan Children* (Figure 4) is
less satirical than that of the California high school students. I was shifting
my context, and therefore my attitude. It was easy to be drawn to the poor

Fig. 2. *Students.* Prismacolor drawing. 1957.

Fig. 3. *Operation Rat Team.* 1957.

Fig. 4. *Taiwan Children.* Conte crayon. 1957.

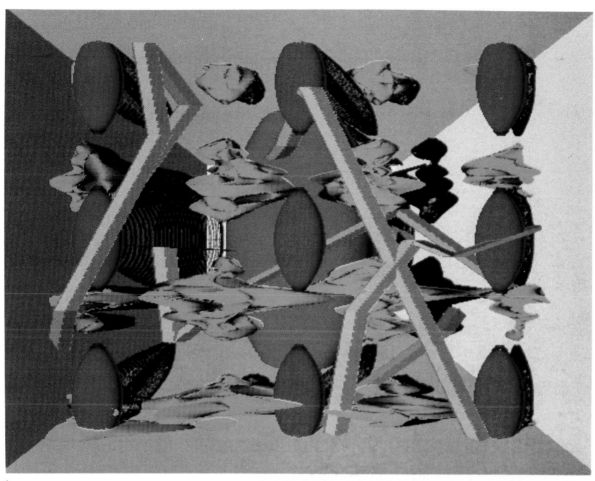

1

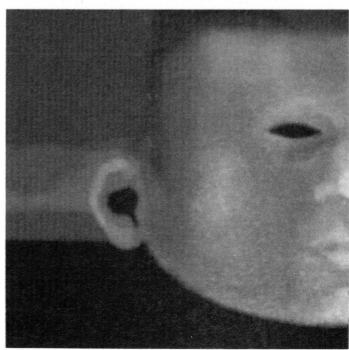

Plate 1. *Space Carrots.* Duane Palyka, Computer Graphics Laboratory, New York Institute of Technology.

Plate 2. *Face.* Duane Palyka, Computer Graphics Laboratory, New York Institute of Technology.

2

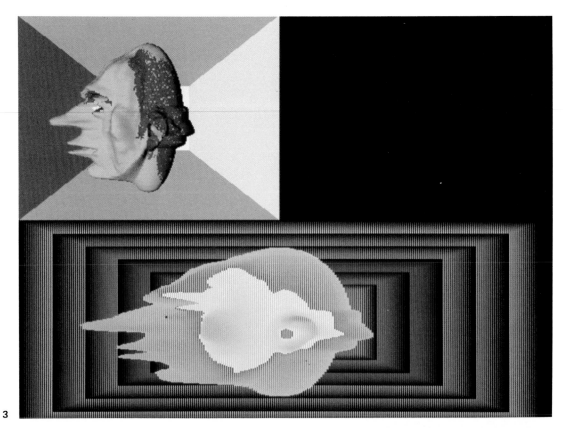

3

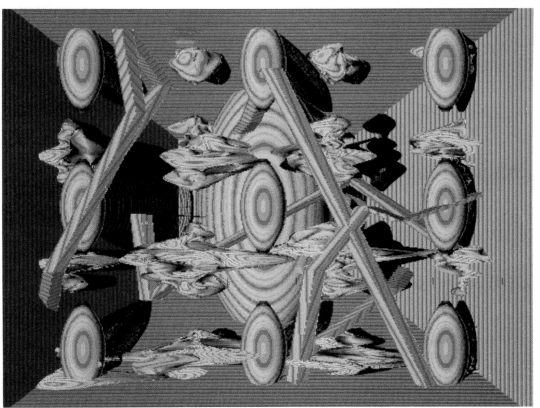

4

5

Plate 3. *Egghead*. Duane Palyka, Computer Graphics Laboratory, New York Institute of Technology.

Plate 4. *Warm-Cool One*. Duane Palyka, Computer Graphics Laboratory, New York Institute of Technology.

Plate 5. *Figure with Aura and Guards.* Duane Palyka, Computer Graphics Laboratory, New York Institute of Technology.

Plate 6. *Sparkling Giacometti Sequence.* Duane Palyka, Computer Graphics Laboratory, New York Institute of Technology.

6

7

8

Plate 7. *Stretched Movement.* Duane Palyka, Computer Graphics Laboratory, New York Institute of Technology.

Plate 8. *Tall Movement.* Duane Palyka, Computer Graphics Laboratory, New York Institute of Technology.

Plate 9. *Stretched Movement Zoomed.* Duane Palyka, Computer Graphics Laboratory, New York Institute of Technology.

Plate 10. *Tex Blob.* Duane Palyka, Computer Graphics Laboratory, New York Institute of Technology.

Plate 11. *Folded Space.* Duane Palyka, Computer Graphics Laboratory, New York Institute of Technology.

9

10

11

Plate 12. *Picasso Two.* Duane Palyka, Computer Graphics Laboratory, New York Institute of Technology.

Plate 13. *Pablo.* Duane Palyka, Computer Graphics Laboratory, New York Institute of Technology.

Plate 14. *Painting 8-72.* Duane Palyka, Computer Graphics Laboratory, New York Institute of Technology.

Plate 15. *Space One.* Duane Palyka, Computer Graphics Laboratory, New York Institute of Technology.

Plate 16. *Warm-Cool One Dipped into Gravity Space.* Duane Palyka, Computer Graphics Laboratory, New York Institute of Technology.

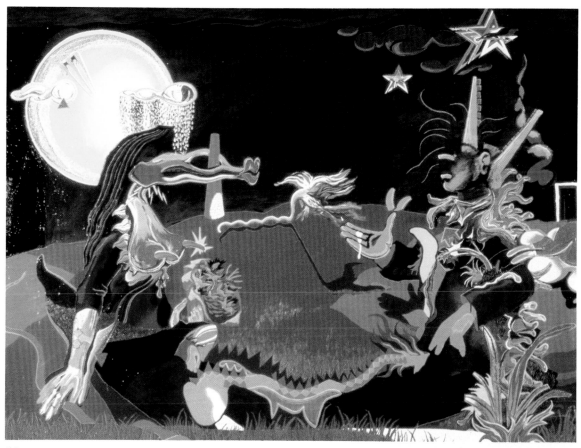

14

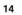

15

16

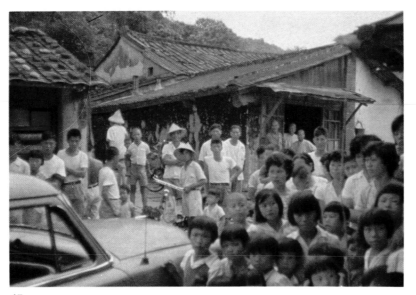

17

Plate 17. *Taiwan Village.* Sonia Sheridan. 1957.

Plate 18. *Looking through the Time Plane.* Sonia Sheridan. Lumena, Time Arts. 1985.

Plate 19. *The Floating Life.* Sonia Sheridan. Woodcut.1960.

Plate 20. *Flowing.* Sonia Sheridan. Handpainted woodcut. 1960.

Plate 21. *Flowering in the Window.* Sonia Sheridan. Ink painting. 1963.

Plate 22. From the series *Hexagon Y with Goethe Color Triangle.* Sonia Sheridan. Acrylic painting. 1965.

Plate 23. *Nightbook Pages.* Sonia Sheridan. 1983.

Plate 24. *Two Shapes Moving in Time.* Sonia Sheridan. 1963.

18

19

20

21

22

23

24

25

26

Plate 25. From the series *Hexagon Y with Goethe Color Triangle.* Sonia Sheridan. Ink painting. 1965.

Plate 26. *Tossed Penny.* Sonia Sheridan. Ink painting. 1965.

Plate 27. *Sonia with Hand Iron.* Sonia Sheridan. One of series, Color-In-Color image ironed onto 3M Thermo-Fax B systems paper, hand iron, and matches. 1971.

28

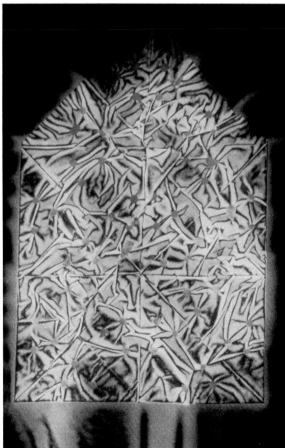

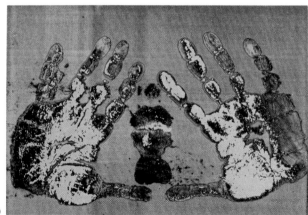

29

Plate 28. *Kneaded Eraser Self-Portrait.* Sonia Sheridan. Museum of Science and Industry, Chicago. Photograph by Diane Kirkpatrick. 1978.

Plate 29. *Sonia Pressure Portrait.* Sonia Sheridan. 3M dry silver paper. 1978.

Plate 30. *Folded and Heated Paper.* Sonia Sheridan. Pressure/flow, 3M Thermo-Fax and Color-In-Color dye sheets with hand iron. 1970.

Plate 31. *Stretching Sonia.* Stretching Color-In-Color image on rubber. 1978.

Plate 32. Stretching/compressing hand from one 3M VRC remote copier to another, holding the recording needle down. Sonia Sheridan. 1978.

Plate 33. *Mathematician's 4-Hour*

and 40-Minutes-Long Hand. Sonia Sheridan. 3M VRCs back to back, holding the recording needle down. Image is six stories high. Xerox Center, Chicago. 1980.

Plate 34. *Wafer, Time Plane Shift.* Sonia Sheridan. Y's as pressure (on plane) and flow (in air), ink painting. 1972.

Plate 35. *See No Evil.* Sonia Sheridan. 1970.

Plate 36. *Think No Evil.* Sonia Sheridan. One of series of 3, Haloid Xerox. Image of sound taped on 3M VRC remote copier, tape replayed with varying volumes to distort image. 1972.

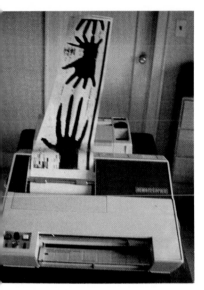

33

34

36

37

39

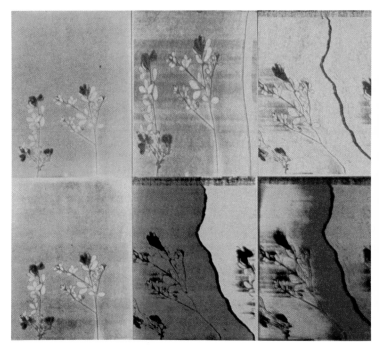

Plate 37. *Test Pattern: People's Fabric.* Sonia Sheridan. 3M VRC remote copier, Color-In-Color. 1973.

Plate 38. *Jim Stretched.* Sonia Sheridan. EASEL software, Time Arts. Video out of sync, reassembled images.

Plate 39. *Weed: People's Fabric.* Sonia Sheridan. Stretching/layering, 3M VRC remote copier, Color-In-Color, Moonbeam fabric. 1974.

Plate 40. *Weed: People's Fabric.* Sonia Sheridan. Thermo-Fax on B Systems paper, hand iron, sound taped on 3M VRC remote copier, Color In Color. 1971.

Plate 41. *The Wheel of Time.* Sonia Sheridan. Ink painting. 1979.

Plate 42. *Riding the Time Plane.* Sonia Sheridan. Ink painting. 1979.

Plate 43. *Wall Notes. Nine Ways of Visualizing Time: Layering/Filtering.*

Sonia Sheridan. Color In Color, notebook pages. 1974–85.

Plate 44. *Weed: People's Fabric.* Sonia Sheridan. Thermo-Fax on B Systems paper, hand iron, sound taped on 3M VRC remote copier, Color-In-Color. 1974.

Plates 45, 46. *My New Black Book.* Sonia Sheridan. Two of series, EASEL software, Time Arts, Cromemco Z-2D hardware. 1983.

41

42

43

44

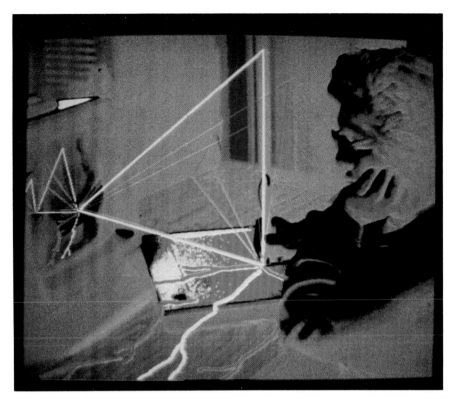

45

46

47

48

Plate 47. *Stan Vanderbeek with Sonia and Nautilus.* One of series. LUMENA software, Time Arts. 1985.

Plate 48. *Electra: After Two Months of Working in the Musée d'Art Moderne de la Ville de Paris with the Population.* Sonia Sheridan. EASEL software, Time Arts, Cromemco Z-2D hardware. 1984.

Plates 49, 51. *Sonia Metamorphosed as Butterfly.* Sonia Sheridan. Infinite series. EASEL software, Time Arts, Cromemco Z-2D hardware. 1983.

51

Plate 50. Baby's drawing on his EASEL video computer image.
Sonia Sheridan. *Electra* show, Musée d'Art Moderne de la Ville de
Paris. 1984.

Plates 52, 53. Child and his drawing on his EASEL video computer
image. Sonia Sheridan. *Electra* show, Musée d'Art Moderne de la
Ville de Paris. 1984.

52

53

54

Plate 54. *Nautilus.* Sonia Sheridan. One of series, LUMENA software, Time Arts. 1985.

Plate 55. *Becoming.* Sonia Sheridan. Thermogram made with two separate 3M Color-In-Color images ironed together. 1971.

55

and innocent Taiwanese street children, who silently watched me as I drew them on the streets of Taiwan. Sometimes I gave a drawing to a child.

The 1957 photograph *Taiwan Village* (Plate 17) was not a conscious part of my artwork. It was requested by my friend, the local village artist, on his wedding day. Only the artist received a copy of the photograph, and that weeks later. In 1957 I could not foresee that a new technology, in the form of computers and copiers, would increase the possibility for sharing and inter-activity between artist and subject. I would have been very surprised if I could have looked ahead to 1984, when I would have the most interactive experi-ence of my artistic career, when I took the Easel/TimeArts computer graphics system to the Musée d'Art Moderne de la Ville de Paris. There I worked side by side with the museum visitors as we made computer-video images of one another and drew on them with the rich, multi-faceted Easel system.

When I lived in the Far East, from 1957 to 1960, I immersed myself in Chinese and Japanese life and literature. The novels *Six Stages of a Floating Life, The Dream of the Red Chamber,* and *The Golden Lotus* deeply affected my attitude toward art. A year in the art department of She-Da University in Taipei, half a year in Toshii Yoshida's woodblock studio in Tokyo, and my friendships with other Asian artists opened up my conceptions of art. I joined the Chinese in admiring the work of Paul Klee. In the two woodcuts made immediately upon my return from the Far East in 1960 (Plates 19, 20), I am floating free yet part of the landscape. In 1978 a mathematician at North-western University, Don Saari, gave me René Thom's book *Morphogenesis and Structural Stability.* Thom's illustration of the growth process of "budding" is the structure that underlies the two figures of the woodcut *The Floating Life.*

Not surprisingly, upon my return to the United States my work shifted to very simplified figures. I began to probe in two opposing directions, exter-nally and internally. By the time I had taught at the Art Institute of Chicago for two years, beginning in 1961, I had begun to make pictures that I would not really understand until fifteen years later. *Flowering in the Window* (Plate 21), a hand-sized ink painting, was a mystery to me until the mid-1970s, when I began to realize that it represented the flowering of consciousness. In the late 1970s I inserted *Diagram of the Structure of Consciousness* (Figure 5) into my sketchbook as part of an objective study; the woodcuts from the 1960s show-ing the structure of growth had been its forerunners. Once I was on the path of discovery, new insights seemed to pile up at a furious rate.

For about eight years before I began to work with machines, I created images and lessons dealing with problems in the visualization of motion. I studied the Bauhaus teachings and the latest scientific writings. I pored over

Fig. 5. *Diagram of the Structure of Consciousness.* Xerox. 1979.

articles in science magazines on subjects such as topology, moirés, communications, perception of grays, and time. I combined objective study with free association, which resulted in paintings and lessons dealing with such problems as pressure/flow, metamorphosis/morphogenesis, stretching/compressing, layering/transparency, synchronicity/simultaneity, and interfering/filtering. It took twenty years to develop my ideas about visualizing space, time and motion—with the assistance of scientists, scholars, students, and a body of literature entirely new to me.

During the 1960s my work took a number of directions. Two opposing positions and the tension of opposites were of particular interest to me. Geometric, man-made forms were placed in juxtaposition with organic, natural forms or studied separately.

The page from the book *The Inner Landscape* (Figure 16) shows the metamorphosis of the Y and is a typical example of my search for a visual vocabulary. (My name on my birth certificate is spelled Sonya Landy; Y is the 25th letter of the alphabet; I was born in 1925; Y upside down is the Chinese character for man.) A series of drawings, paintings, and constructions, *Hexagon Y with Goethe Color Triangle,* involved stretching and compressing shape and color (see Plates 22, 25). Another series, exemplified by *Tossed Penny* (Plate 26), relied on random tosses of a coin to determine the position of four different but related squares.

In 1969 I found the silkscreen process too slow for rapid communication;

then I stumbled onto copiers. When my work with hand tools was thus supplemented with high-speed electronic tools, an entirely new world opened up to me. For every "dream" I painted, the new technologies validated the dream as merely another aspect of reality. For the next decade I was directly involved with industry in the development of these tools for art use.

As part of my work with these new tools, I held many workshops and participated in interactive exhibitions. Two of the earliest of these were a 1969 exhibit entitled "Interactive Papers" at the *Software* show in the New York Jewish Museum and a 1970 workshop at the Chicago office of 3M with students and faculty from the School of the Art Institute of Chicago. In this manner I continued to work at a social level. The social involvement, however, was preceded by months of solitary experimentation, especially with the 3M Thermo-Fax and Color-In-Color system, the latter as artist-in-residence in 1970 at 3M's Color Research Laboratory in St. Paul, Minnesota. The experiments from this period included many of the problems I had worked with earlier, only now I was using materials that allowed for thermal, electrostatic, and magnetic use of energy.

These experiments became the foundation for the Generative Systems program I established at the School of the Art Institute of Chicago in 1970.

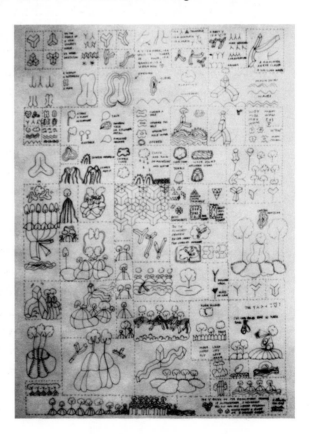

Fig. 6. Page from *The Inner Landscape.* 1965.

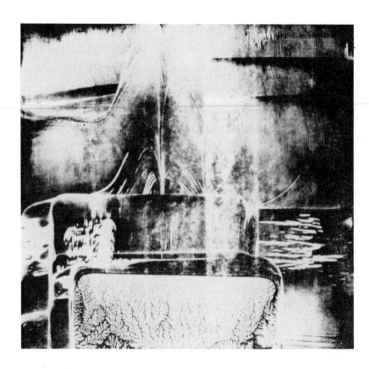

Fig. 7. *Pressure/Flow.* Lithograph made by pressing two litho stones together. (Tusche between stones) and lifting quickly (bottom), and gliding two lithe stones together for wave (top). 1960.

The program grew into a full area of study with a graduate program by 1975. The new teaching context provided me with an expanded range of possibilities for the visual exploration of the dimensions of time and space. By 1979 I had formalized ways of visualizing time, for a course entitled "Homography": scanning/closure, pressure/flow, stretching/compressing, layering/transparency, metamorphosis/morphogenesis, synchronicity/simultaneity, internal/external, interfering/filtering, mind-generating/machine-generating.

By 1985 I had assembled twenty years of images—including a dozen different technologies, with electrostatics, magnetics, heat, light, chemicals, and electric and light transmission—into *Wall Notes: Nine Ways of Visualizing Time.* The images in Figs. 7–13 and Plates 27–55 show some of the experiments I tried and the ideas I explored through the years.

Fig. 8. Stretching/compressing pen, kneaded eraser, and stamp pad (right). Lessons for two-dimensional design and printmaking. 1969.

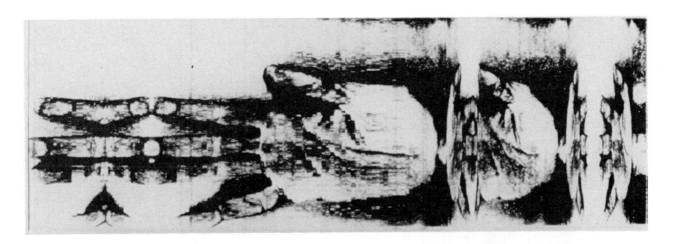

Fig. 9 (above). *Stretched Hand*. Stretching/compressing on 3M VRC remote copier, 3M Central Research Laboratory. 1978.

Fig. 10 (right). *Scientist's Hand*. 3M VQC image on computer card top line; the distortion was made by shifting cards visually rather than mathematically. 3M Central Research Laboratory. 1978.

When I left the Art Institute of Chicago, I had created for the Generative Systems program (now ten years old), three new courses of study: Process I, Process II, and Homography. The process courses were created to explore systematically uses of energy for art, especially those forms of energy seldom used by artists. To these courses I later added another—Experiments in Developing Computers.

A dynamic program and dynamic art come from dynamic interactivity of many people and forces, many places and institutions. The Generative Systems program drew its strength from large numbers of individuals and institutions, who provided me with a rich working environment. Those individuals and institutions are now part of the worldwide Generative Systems Network. I am still actively working with many who participated with me in the Generative Systems program. Although my work grew out of my own persona, I was most fortunate to have had an invaluable family heritage and a dynamic working environment. In this context, after thirty years, I am still searching, still shifting vantage points.

Fig. 11. Notebook page, layering. 1979.

Fig. 12. *Sonia in Time.* VQC, stretching/layering. 1974.

Fig. 13. *Sonia's Mother, Father, and Son.* 3M VQC, layering in time. 1974.

The Cybernetic Dream of the

Twenty-first Century

MORRIS BERMAN

> [I]n the future the community of the learned will have to propose this new and humane theology which is natural philosophy and positive magic. . . . However, if the sense of the individual (i.e., of particular entities) is the only good, how will science succeed in recomposing the universal laws through which . . . the good magic will become functional?
>
> (William of Baskerville, fourteenth century, in Umberto Eco's *The Name of the Rose)*

> [T]he main point is that the world of life is to a great extent created and maintained through the expression of emotional energy. It is this energy through which magic operates. . . . The control and manipulation of emotional energy is the secret of all magic.
>
> (Father Sylvan, in Jacob Needleman's *Lost Christianity)*

Over the last few decades, several critics of modern science have been able to demonstrate that science is not a value-free instrument for ascertaining truth, as many believe, but is rather a mode of cognition whose very "neutrality" constitutes its bias. That is to say, science is ultimately *zweckrational* (purposive-rational); it projects a world of pure form that can be bent to any purpose. In the last analysis, "value-free" really means "possessing scientific values." As the awareness of the ideological and culture-bound character of science began to grow over the past twenty years, Europe and North America experienced a twin development that reflected the need for a new epistemology. One aspect of this was a revival of magic and occult practice.

76

The magical world view was attractive because it is strongly value-laden, biased toward an ecological or sacred view of nature; and unlike its scientific counterpart, it is embodied—sensuous and concrete rather than formal and abstract. The second aspect of the search for an alternative mode of consciousness was the emergence of a large "new paradigm" literature, which draws heavily on fields such as systems theory and quantum mechanics—those branches of knowledge that have departed, epistemologically, from the mechanism and reductionism of classical physics. This new "holistic paradigm," which relies heavily on cybernetic theory for its elaboration, claims to be a major shift in the history of Western thought; for in addition to its break with scientific materialism, it also claims to be value-laden rather than value-free and, as such, a major step forward in the evolution of consciousness.

It is the argument of this article that, as things currently stand, most formulations of the new holistic paradigm are neither value-laden nor significantly discontinuous with the scientific world view of the last three centuries. Instead, they represent the philosophical aspect of a much larger process going on in society today that can loosely be termed "cyberneticization," or the rise of a "computer consciousness," a process that is now unfolding on three levels. The first level, as already noted, is that of abstract philosophy, and includes figures such as Ken Wilber, David Bohm, and Douglas Hofstadter. The second level is that of the professional disciplines, such as biology, ecology, and psychology, in which an information theory terminology is now being used to redefine the central concepts of these fields. The third level, the grass-roots level, is that of the home computer and the video game, which are starting to pervade the environment in a dramatic way. As different as these three levels seem, a similar process is occurring on each: a purely formal, disembodied, and abstract reality is informing the mode of perception and cognition held by those engaged in the activity. On the level of the video game or home computer, the impression created and reinforced for the participant is that reality is a matter of programming. On the professional level, real-life situations are being translated into the jargon of information exchange. And on the philosophical level, reality is now seen as a matter of "mentation" or "symbolic patterned activity." On all of these levels, life is being neutralized, rendered "value-free"—a condition that many proponents of artificial intelligence regard as an achievement. The new holistic paradigm is thus not really a substantive methodological shift from the scientific paradigm that preceded it. As in the case of its predecessor, it too is formal, abstract, "value-free," and disembodied. Based on the computer rather than on the clock (the model for Cartesian mechanism), cybernetic holism is in reality the last outpost of the mechanical world view.

As the transition from mechanism to holism inevitably continues into the twenty-first century, we shall have to be wary of what is happening, and start to make distinctions between varieties of holistic thinking. If we wish to avoid the pitfalls of the previous paradigm, we cannot afford to leave the insights of the magical tradition behind. By "magic" here I mean the affective, concrete, and sensual experience of life. This would be a paradigm grounded in the real behavior of people in the environment; one that would incorporate the sort of information that arises from our dream life, our bodies, and our relationship to plants, animals, and natural cycles. The alternative view—the belief that we can do without such things, that we can profitably regard reality as pure metaphor, "programming," or "patterned activity," that we can neutralize the pain and conflict of human life by what is in reality the latest technological fix—this is the cybernetic dream of the twenty-first century.

Science as Myth

It was in the mid- to late 1960s that an idea with a long but obscure ancestry finally came to fruition, an idea that many of us, myself included, found very difficult to grasp. This idea was that science possessed no epistemological superiority over any other mode of thought; that it had no monopoly on the truth; and that, in the last analysis, it was a mythology—that is, it functioned as a type of religion for Western industrial societies. On the popular level, this argument was most closely identified with Theodore Roszak, who asserted that science was not some sort of absolute, transcultural truth but, rather, a type of cultural construct; a "construct in which a given society in a given historical situation has invested its sense of meaningfulness and value" (Roszak, 1969, 215).

Why was this argument so difficult to grasp, let alone accept? Largely because all of us were brought up within those very philosophical parameters Roszak had chosen to call into question. These parameters have their origins in the Scientific Revolution of the seventeenth century, and are generally summed up by historians of science as the "mechanical philosophy." Briefly, this states that spirits of any kind are delusions, that consciousness is epiphenomenal (i.e., arises from a material base), and that matter and motion are the only real entities around. The favorite image of the universe was that of a clock, wound up by the Almighty to tick forever. Nature was thus seen as mechanical, and all explanations of its behavior had to be material ones. And for the most part, this is still what the dominant culture believes, as can be

seen by consulting any modern textbook in the natural or social sciences, or, for that matter, the daily newspaper.

Roszak's idea, as I have already indicated, had a long tradition behind it; a tradition, interestingly enough, that was heavily academic in nature. Edmund Husserl, Martin Heidegger, and Ludwig Wittgenstein had all broached the subject in various forms. The Frankfurt School for Social Research, notably Max Horkheimer and T. W. Adorno, had wrestled with these problems in books such as *Eclipse of Reason* and *Dialectic of Enlightenment.* And the so-called "externalist" school of the history of science, following up on the general mode of analysis provided by Karl Mannheim, pointed out that both the content and the method of modern science were "situation-bound," highly localized in time and space. In other words, modern science was put together over a period of roughly 150 years, and principally in four countries— Italy, England, Holland, and France. If you studied the social, economic, and religious history of those nations between 1550 and 1700, you began to understand why scientific conceptions of reality would take root at that time and in those places. The logical conclusion was that this whole mode of perception was and is a cultural construct, a mythology, a complex and elaborate world view that permeates Western industrial societies and provides them with meaning (Husserl, 1970; Heidegger, 1977; Mannheim, 1936).[1]

Science as Value-laden

During the 1960s, however, the real critic of the scientific world view was not Theodore Roszak but Herbert Marcuse, whose book *One-Dimensional Man* (1966) constituted a major attack on the claim of science to be value-free. At a time when it was still fashionable to argue that science and technology could be used for good or evil, Marcuse argued that science possessed no real neutrality, but was from its inception haunted by a particular bias, which he termed the "logic of domination." His attack, paradoxically enough, was based on an examination of the one feature that modern science regards as a *guarantee* of its neutrality: its purely formal or abstract character. In a word, the science of Galileo is about relata, not about contents. The law of free-fall, $s = kt^2$, is descriptive rather than normative. Where Aristotle saw a falling body as going "home," moving toward the center of the earth, and thereby living out its teleological destiny, Galileo saw only an abstract relationship between distance and time. Modern science is thus based on the abolition of the notion of *telos,* or inherent purpose, and it does this by positing a purely

formal reality, one that can be bent to any situation. But it is precisely here, said Marcuse, that it reveals its bias, for the ability to be bent to any situation implies a purely instrumentalist character. $S = kt^2$ has a latent but powerful message, for it projects a world of pure form and essentially says that only this is real. In Galileo's time, it was still possible to maintain a notion of two realities. Hence the father of modern science, as he has been called, supposedly argued before the Inquisition that "physics tells how the heavens go; it does not tell how to go to heaven." But it proved to be a feeble dichotomy, and one difficult, as the centuries passed, to maintain.

The two realities ultimately collapsed into one; hence the title of Marcuse's book. And having left value behind, this single dimension of reality could then claim to be value-free. But it was precisely this point that Marcuse chose to call into question, arguing that this very neutrality constituted the bias of the whole methodology. There could be nothing neutral about a methodology, said Marcuse, that swallowed up the entire *Lebenswelt* —that created, for literally everyone in the culture, a single mode of seeing and interpreting the world. "[W]hen technics becomes the universal form of material production, it circumscribes an entire culture; it projects a historical totality—a 'world' " (Marcuse, 1966, 154). Amorality, in short, was a species of morality: "Value-free" really meant "scientific values."

Eruption of Magic

The combined result of all of this type of thinking, or at least conspicuously concomitant with it, was the eruption, in Europe and North America, of cults of various sorts on an unprecedented scale. The feeling was, quite simply, that science had gone astray, that if it were a mythology, there were reasons to believe it had outlived its time, and that other realities were equally valid or perhaps even superior to it. By the mid-1970s, interest in the occult was extremely widespread. Astrology, alchemy, sorcery, numerology, witchcraft, Scientology—not since the heyday of the Renaissance had the nonrational enjoyed such a vogue. This was partly explicable in terms of the growing disenchantment with science; but one still has to ask, "Why magic?" What was there about the occult tradition that was so attractive to a large counterculture that was jaded with science? There are undoubtedly many answers to this, but I suspect that one of the most important is that magic has strengths in precisely those areas in which, according to Marcuse, science is weak. The occult sciences are anything but formal and abstract. They are sensuous and

concrete, and magical rituals typically engage all of the senses, including taste and smell. Magic is embodied in a way that science is not; it emerges from the whole person, not just from the intellect. And although magic certainly has a manipulative or exoteric aspect, its historical context down to the early modern period was a sacred one. That sacred (or ecological) context meant that, in overall terms, magic was not value-free or instrumentalist, and there was always a severe injunction against using it in a purely manipulative way. Goethe's *Faust* is in fact a modern version of this ancient injunction: the attempt to divorce fact from value has a price, that being nothing less than the loss of the soul. As Marcuse recognized, that divorce is the essential drama of the modern era.[2]

Finally, magic was attractive because it provided an epistemological shock. Many of those who got interested in magical practice, myself included, had a real surprise in store: it works. Reality is flexible enough that perception can influence it; in fact, that is why *science* works, and why it can rightly be called the magic of the modern era. As it turns out, the occult subculture was not the only circle that was interested in alternative realities. Soviet and American intelligence organizations had been investigating ESP, psychometry, psychokinesis, and such since the 1950s or 1960s, and discovering what magical practitioners have known for centuries: mental attitudes can make a difference for physical effects.[3]

As noted, all of this suggested to many people that Western consciousness may be in the midst of a mythological shift, or that a new scientific revolution might be in progress. This perception, however, was definitely not confined to investigators of occult phenomena. A large "new paradigm" literature began to develop, arguing for a convergence of modern physics and ancient historical tradition, for example, or seeing in ecology or systems theory a new mode of constructing the world (see, e.g., Capra, 1975; Zukav, 1979; Bentov, 1977). As for myself, I played with magic long enough to satisfy my intellectual curiosity; but I have to confess that I never managed to acquire any great magical powers. Furthermore, my interest was in a post-Cartesian philosophy, not a pre-Cartesian one, and this pretty much put me in the "new paradigm" camp. And it was at this point that I stumbled across the work of the cultural anthropologist Gregory Bateson, and found what I was looking for: a scientist who talked like an alchemist. Precise, empirical, experimental, Bateson's categories of thought nevertheless had a living, sensuous quality to them. As I began to wade through the opaque prose of his book *Steps to an Ecology of Mind* (1972), to puzzle over essays such as "The Cybernetics of 'Self'" and "Form, Substance and Difference," it began to

dawn on me that this man had somehow managed to bring fact and value back together in a way that was rationally credible. And although he often used a cybernetic or systems theory terminology, the pages of the book oozed life, because the theory emerged not from abstractions but from concrete situations. Patiently, over the decades of his life, Bateson lived and studied among the Iatmul of New Guinea, the Balinese, alcoholics, schizophrenics, dolphins—it was from such contexts that his most famous concepts, such as schismogenesis, circuitry, and the double-bind, had emerged. Bateson was the living embodiment of his own theoretical analysis; the philosophy was incarnated in the practice. This was a "process" reality, formally identical to the magical tradition, yet radically different in content. There was a clear resonance with Taoism, with quantum mechanics, with the work of Carl Jung and Wilhelm Reich; and it spoke directly to questions of ecology and our relationship to the environment. The Gregory Bateson of *Steps*, I concluded, could well be the most brilliant and most desperately needed thinker of the twentieth century; and that is a view I would still, to a great extent, defend.

Bateson Disembodied

Unfortunately, in his later work, Bateson was not able to hold the synthesis of the sensuous and the scientific—what Umberto Eco calls "natural philosophy and positive magic"—together. The first hint that something was amiss occurred to me in 1979 when Bateson, in the year before his death, published *Mind and Nature: A Necessary Unity*. The holistic epistemology of *Steps* was still there, all right, but despite the subtitle of the book, mind and nature were tending to float away from each other. In Bateson's revision of Darwin, for example, evolution was presented almost entirely as a mental process. Real dinosaurs and butterflies seemed to be absent from the picture. By mid-1980, just before Bateson's death, his tendency was taken to its logical conclusion. His last talk, "Men Are Grass: Metaphor and the World of Mental Process," solves the mind-body problem by doing away with the body altogether. The cybernetic philosophy presented there is, when you come down to it, essentially Neoplatonic or Augustinian. The flesh withers, the soul is immortal—a convenient philosophy, of course, if you know you are about to die, but a retreat from reality and into a world of pure abstractions nonetheless. By turning into pure form, Batesonian holism succumbed to the very problem that haunted the mechanical philosophy.[4]

Those who seriously reject mechanistic science today largely fall into the two categories I have identified: occult practitioners and what we might generally call cybernetic or holistic thinkers. I am not going to say anything further about the first category, principally because I do not believe it has any real future: it is very unlikely that we can turn back the clock and revert to an earlier era and world view, and I am not convinced it would be a good idea in any event. My attention, therefore, will be focused on the second category; but it is here, quite frankly, that I have begun to have some serious doubts. Whereas Bateson managed, at least for a time, to hold mind and matter together, the holistic or cybernetic thinking of the 1980s is simplifying the problem by dispensing with matter before the game even begins. The result is that on the philosophical level, we now have an emerging epistemological consensus that, in one form or another, claims to refute and replace the mechanism and materialism of the last 300 years, but that, in most of its forms, falls prey to the same philosophical problems that plague modern science as they were identified by Herbert Marcuse. That is, it is purely abstract and formal, capable of being bent to any reality; and it often has the appearance of being value-free, but in fact projects a *Lebenswelt,* a total vision of reality that circumscribes an entire world.

Nor is this occurring just on the philosophical level. The new mythology is now appearing at three levels of society, levels that overlap, interpenetrate, and reinforce one another and that are often difficult to distinguish. The first, as noted, is that of abstract philosophy, which includes a rather eclectic mélange of writers and scientists, figures as diverse as Ken Wilber (1977, 1980, 1983), Marilyn Ferguson (1980), David Bohm (1980), Douglas Hofstadter (1979), and Rupert Sheldrake (1981).[5] The second level is that of the professional disciplines, including history, biology, education, ecology, and psychology, to name but a few. The third level is the daily life of the ordinary citizen, which is increasingly filled with video games and home computers. Of course, the three levels are not identical; and in sociological terms, there is no way I can prove they are even related. Yet it seems to me that it would be naive to believe that this new mythology had somehow emerged within our culture at three different points and that these three manifestations were nevertheless not part of the same social process; and I am going to take it as a given that they *are* structurally related, even though I cannot establish any concrete casual connections. Taken as a whole, these three levels serve to propagate the mythology of a new "process" reality, a type of abstract "mentation" or consciousness that, despite a fanfare of propaganda about being a

new liberatory epistemology, is in fact just as disembodied and "value-free" as its mechanistic predecessor. These are the problems I see operating on all three of these levels and that I wish to make the focus of my critique. I shall return to the level of abstract philosophy, or "new paradigm" literature, toward the end of this essay. For now, let me concentrate on the more concrete manifestations of the new cybernetic consciousness.

Computer Consciousness: A Form of Psychosis?

In many ways, the grass-roots level is the most significant, the more so for being the least sophisticated. The Italian historian Carlo Ginzburg (1980, 1983) has argued that the way to discover what a culture is about is not to study the ideas of its leading intellectuals but, rather, to examine what fills the heads of its ordinary citizens. Unfortunately, we are at something of an impasse here, for it would seem to be a bit too early to discern this. As far as I am aware, no exact studies have been done of the impact of video games or home computers on the personal or individual level, so I am going to have to rely on general impressions. And the image I have—all of you have seen it—is of a group of teenagers crowded around a Pac-Man machine in a drugstore or games arcade. The thing that interests me most here is the eyes of the players. Have you ever observed the eyes of someone playing Pac-Man? They are glazed. The phrase that recently entered the English language, "video addict," is quite apropos, because the machine instantly takes the player out of this world. He or she becomes, in effect, unconscious; his or her eyes take on an absorbed, drugged quality that reflects the all-encompassing power of the screen. As with any drug, the video screen effectively enables the addict to leave his or her body and thus the cares of the world. An organization called "Vidanon" has recently emerged, dedicated to freeing people from this addiction.[6]

In this way Pac-Man, and frequently the home computer as well, is really the modern fulfillment of the Gnostic vision. For whether the screen presents a computer program or asteroids to be blown out of the sky, it enables the user to escape, at least momentarily, from boredom, anxiety, and other emotional difficulties, all of which are felt in the body. This is not to say that home computers are identical to video games in terms of intended use, but as things work out in practice, both encourage disembodied activity and help to diffuse a similar mode of perception throughout the culture. In this way our culture is starting, without much questioning or critical evaluation, to acquire a kind of "computer consciousness." Strictly speaking, home computers fall

into the category of professional activity; but it is doubtful that all or even most of the 27 million units sold between 1978 and 1983 are being used in this way.[7] Exact mode of use, however, is not the point. The real issue here is that both video games and home computers create a similar view of the world for millions of people. Both present the viewer with a screen and a set of images to be operated upon. Both convey the notion that reality is a function of programming, and children as well as adults pick up a certain type of vocabulary from their use. The general result, I suspect, is a vast subculture that lives entirely in its head, that sees reality as essentially neutral, value-free, and, especially, disembodied, a form of pure mental process.

An example of what I am talking about was provided for me by a friend of mine named Susan, who teaches high school in northern Florida. Many of her students have home computers. When Susan assigns a paper topic, her students immediately run home and feed all the key words into their machines, which are hooked up to various data banks and library resources, and proceed to string this information together. The resulting essays tend to look like speeches given by Ronald Ziegler when he was press secretary to Richard Nixon. One of Susan's students, Frank, stayed after class one day to show her his mass of computer printouts on the latest topic she had assigned. "Frank," she finally said, "stop a moment. I think it's great that you've gathered all these facts about the subject, but put them aside just for a second. Look at me and tell me in your own words: What do you *feel* about this issue?" Frank stared at her for a moment and finally replied, "I don't know what you mean." Susan told me that if she could afford it, she would retire to Key West and spend the rest of her life scuba diving. In fact, she may not have long to wait. Increasingly, the thrust in secondary school education is to do away with teachers entirely. In one survey conducted by the Sperry Univac Corporation, 50 percent of the high school students polled said they would prefer to be taught by a machine, and gave us their reason that they wished to be left alone (see note 7).

I feel very uneasy with developments of this sort; they reflect a situation in which people get completely caught up in a world view without any notion that such a thing is happening to them. And I fear we are going to see much more of this in years to come. Recently, the University of Victoria concluded an agreement with IBM Canada whereby the two institutions will work together to develop applications for computer software that will be used by students from the kindergarten level up. Computers are also being designed for the purpose of rocking a baby's cradle and singing it lullabies. "It is already technically possible," said Seymour Papert, professor of mathematics and education at M.I.T., "to make a machine that can interact with a child

from the beginning of its life." Papert's research team discovered that infants can become addicted to computers, and he comments that the interference in parent-infant bonding by such machines is a turning point in the history of child rearing. By cutting these early ties, he says, "we could easily turn up a generation of psychotic children, of psychotic adults" (*San Francisco Chronicle,* 1983). Susan's student, Frank, may seem like an aberration today, but a decade from now he may be fairly typical. Three decades from now, there may be no problem, in that there may be no one around who does not possess a cybernetic consciousness. The "psychotic" label is a matter of social definition. In a predominantly psychotic world, psychotic becomes healthy, and healthy, psychotic. It seems to me that we ought to stop and think about developments of this sort before the level of daily life is completely transformed.

Cybernetics Applied to Professional Disciplines

Let me turn now to the second level I referred to, that of the professional disciplines. I have no opposition to cybernetic technology *qua* technology; its utilitarian aspect is not the focus of my critique. Computer technology clearly makes possible a number of desirable things, such as scanning the retina in eye operations or arranging airline flights and schedules. This makes it a valuable tool, and I am personally glad it is available for such things. What I am worried about, as I presume is obvious by now, is how it acts on the emotional, social, and perceptual level of human existence. What is the widespread adoption of all this hardware and software doing to our modes of perception, and our relationship to ourselves, to each other, and to the environment? At the level of professional research, the impact is becoming more noticeable every day.

In the field of professional history writing, and indeed in virtually all of the social sciences, computer studies have become the sine qua non for obtaining a grant and, in some cases, professional respect. Robert Fogel and Stanley Engerman's classic work of a decade ago, *Time on the Cross* (1974), is a case in point. The computerized data enabled the two historians to argue that the system of slavery in the American South was really part of the cash economy and thus that, in material terms, American slaves were not really an oppressed population. A number of scholars subsequently challenged the way in which the authors used and interpreted their statistics, and were able to throw the argument into serious doubt. Yet the major issue, it seems to me—and some reviewers did point this out—is that there is something

seriously amiss with the methodology being used, beyond the question of faulty statistical analysis. What this methodology can never capture is the experience of slavery as it was actually lived; this can only be recaptured, if at all, through testimonial evidence. There will, of course, always be the problem of how representative any testimony is. But at least this sort of evidence is not blind to the subjective experience of daily life. As one black reviewer remarked, "There are differences between being slave and being free, even if those distinctions cannot be analyzed by high-speed computers" (Huggins, 1974).[8] Yet for the most part, historians and social scientists have tended, in the ensuing decade, to *follow* the path blazed by Fogel and Engerman, rather than realize that it is ultimately a dead end. And as they plunge deeper and deeper into this rarefied atmosphere of quantitative analysis, it is the vital subjective dimension of human life that starts to recede from view. Attitudes, perceptions, ideologies, emotions, modes of cognition, frequently even class affiliation— none of these things is very amenable to computer analysis, and as a result, they all increasingly tend to get dropped from the research agenda and thus from the historical picture in general.

A good deal of historical research is now being designed with the computer in mind. The tool is thus becoming the master, rather than the servant, and in doing so it creates a skewed version of what the historical record actually contains. Unfortunately, it is in the omitted areas I mentioned that we tend to find the real life of human beings, the locus of meaning, and the value system of a culture. As Chilean biologist Francisco Varela (1983) once remarked, the hard sciences deal with the soft questions and the soft sciences with the hard ones.[9] The more the humanities, history, and the social and behavioral sciences succumb to the glamor and professional pull of computer analysis, the more precise they will be and, I suspect, the less they will have to say.

The popular belief with respect to these fields is that we are learning more because we have more information available. In fact, the range of thought is actually being *narrowed,* because all of the information is of the same kind. In Orwell's *1984,* the goal of the state was to create a system of thought that embraced all the rest. This is what is effectively happening, albeit not through any deliberate conspiracy. The technology itself discourages any kind of thinking that jumps the rails, which is central to truly creative work; and this narrowing tendency is rapidly being incorporated into institutional procedures. Some universities in the United States are now considering the feasibility of putting the card catalogues of their libraries on computer tapes, which will do the searching for you. One university library has apparently closed its stacks to students and faculty alike, and all search and

request work is done by computer terminals. The outcome of this sort of thing should be obvious. Many scholars will tell you that their best finds have come through pure chance: they went to the stacks to locate some particular item and accidentally stumbled across a book that proved to be a revelation, that altered the entire direction of their work. The new system would make such serendipity impossible.

History and the social sciences are not the only disciplines that are being cyberneticized. At least three other fields I can think of—ecology, biology, and clinical psychology—are now being heavily influenced by a systems theory approach. The dominant trend in American ecology since World War II has been increasingly reductionist and managerial. The cybernetic approach is to abstract data from the organic context in the form of "bits" of information. These are then manipulated according to a set of differential equations to generate a "trajectory" for the ecosystem and plan its "rational" management. The word "ecosystem" itself comes from systems theory, having been developed to replace the older, more organic phrase, "biotic community." The cybernetic approach to resource management is perhaps exemplified by the Club of Rome, which sees the planet not as a web of life with regional peculiarities, but as an abstract globe whose resources can and should be moved around according to ecosystem trends formulated by simulated cybernetic models. The result is the destruction of the holistic vision, or organic unity, that lies at the heart of the human/nature relationship, in no less effective a way than the science and technology of the modern era managed to do. This is no less a disenchantment of the world than the one referred to by Max Weber, no less a logic of domination than the one discussed by Herbert Marcuse. Waving a holistic banner here in the name of ecology is truly meaningless.[10]

Cybernetics has also made great headway in biology, and recent textbooks, as well as numerous research papers, are starting to describe living organisms as "systems of information."[11] In his book *Algeny* (1983, 191, 213, 221, 228), Jeremy Rifkin notes that "survival of the fittest" is being replaced by "survival of the best informed." Life itself is now described as "self-programmed activity." Rifkin warns that if a New Age is indeed dawning, it is the Age of Biotechnology, in which "cybernetics is the organizing framework . . . the computer is the organizing mechanism, and living tissue is the organizing material." What is disturbing about this, as in the case of ecology, is that, originally, holistic thinking held out the promise of abolishing the fact-value distinction attacked by Marcuse, and of restoring the sense of nature as being alive and sacred. Instead, just the opposite is happening. The one professional field most clearly directed to the study of life is becoming

totally disembodied in its theoretical approach—a continuation of the mechanistic paradigm, when you come down to it. "Life as information flow," writes Rifkin, "represents the final desacralization of nature."

Clinical Psychology Scientized

My third and last example of cybernetics come to the professions is that of clinical psychology. On the popular level, and therefore probably the most significant one culturally, a genre of self-help books has appeared, designed to get the reader to induce changes in his or her life by thinking of him- or herself as a cybernetic system. By and large, these books are translations of Norman Vincent Peale or Dale Carnegie into cybernetic terminology. In *Psycho-Cybernetics* (1969), Maxwell Maltz describes the human unconscious as a "goal-striving 'servo-mechanism' " and tells his readers that they can achieve their goals by getting this mechanism to oscillate between positive and negative feedback signals. Eugene Nichols, in *The Science of Mental Cybernetics* (1971), provides his readers with twenty-three "mental-action cards," sketches of IBM punch cards with slogans on them. Terms such as "input," "feedback," and "mental data processing" fill literally every page.

Although I regard all of this as somewhat amusing, and, to tell the truth, somewhat sad, it cannot be dismissed as aberrant or even as a misapplication of the cybernetic idea. It is only an *application* of the theory, not a *mis*application, for the concept of self-corrective feedback is central to all varieties of cybernetic thinking and there is no convincing reason, from a theoretical point of view, why it should not get extended to human interaction. And it is not aberrant, because it is precisely through this sort of popular usage that a world view most effectively spreads. The same thing happened in the early modern period in Europe, when expressions that reflected the clock metaphor began to appear, such as "running like clockwork" or "I'm all wound up."[12] In a similar fashion, we now have a jargon, at least as far as therapy is concerned, that urges the patient to "erase old tapes" and "reprogram the consciousness" so that negative events no longer "push his or her buttons." And within the last few years, a whole new therapy, called Neuro-Linguistic Programming (NLP), has arisen, which is based explicitly on a cybernetic model.

It would be difficult to find a better example of disembodied consciousness, fact-value split, desacralizaton of nature, and the projection of pure form than NLP. It is truly a New Age gem. The bible of the movement, significantly titled *The Structure of Magic,* by Richard Bandler and John Grinder

(1975), was put together by observing three of the great therapists— Virginia Satir, Fritz Perls, and Milton Erickson—at work, and generating a cybernetic model of what they were doing when they treated their patients. All of these three were or are intuitive geniuses, akin to Zen masters, and their talent is legendary. What Bandler and Grinder did was to break down all of their therapeutic interactions into "bits" of information and then reassemble them into a generalized cybernetic pattern. Hence, the "structure of magic," which they have supposedly distilled and scientized.[13]

The thesis here, and the authors are clear about this, is that the scientized version of the original therapy is transferable; that anyone with half a brain can copy and apply it successfully. "Our purpose in this book," they write, "is to present to you an explicit Meta-model, that is, a Meta-model which is learnable." They emphasize that the model is purely formal and content-neutral, and claim that this makes it universally available and universally applicable. What the authors fail to grasp, as far as I can see, is that the structure of magic is not the same thing as magic itself. Fritz Perls was able to heal people not because he was following some cybernetic formula, but because of his physical presence, his personal power. Like Erickson and Satir, Perls was a wizard. He had a genius for grasping what his patient's drama was, tricking him or her into psychological dead-end around the issue, and catalyzing an emotional breakthrough. The crux of his talent was ineffable, and it was hardly a matter of technique.[14] This is what makes the whole approach of NLP so bizarre. What we have here, once again, is really mechanism in updated clothing; we are no better off for having invented a "process" model of therapy.

Holism Gone Astray

So much for the professional and grass-roots levels of society. As for the philosophical level, I must confine myself to one or two examples of the work of holistic thinkers. It is not an easy task, in any event. The epistemological issues are complex, and one cannot, as Marilyn Ferguson (1980) wishes to do, lump all "process reality" thinking together. There are varieties of holism, and real differences between them. And yet, with few exceptions (such as Gregory Bateson's earlier work), all of this theoretical analysis is subject to the same criticisms Marcuse made of mechanistic science.

To anticipate some of my conclusions for a moment, classical science and much contemporary holistic thinking (which includes cybernetic thinking) turn out to be not all that different. Both appear to be value-free, at first

glance, and yet can be shown to project a *Lebenswelt,* a totality that circumscribes an entire culture; both generate a purely formal, abstract reality that can be bent to any situation; and both are disembodied. Cybernetic thinking and, more generally, holistic thinking do not automatically get you out of the world of Newton and Descartes, as so many holistic theoreticians claim. The cybernetic mechanism may be a more sophisticated model of reality than the clockwork model of the seventeenth century; but it is still, in the last analysis, a mechanism. Two types of holism thus have to be distinguished here: the one, a sensuous, situational, living approach to process, such as is exemplified by the early Bateson; the other, an abstract form, a type of "process mechanism," which is present in the work of many philosophical spokesmen of the New Age, and which, in a now more psychologically appealing garb, really represents the last phase of classical science, not the beginning of a new paradigm at all. Cybernetics and general systems theory turn out to be the last outpost of the mechanical world view—a continuation of the scientific project of the seventeenth century rather than the birth of a truly new way of thinking.

As noted earlier, many examples of "holism gone astray" are available. To combat the mechanical philosophy of the last three hundred years, we now have "implicate orders," "morphogenetic fields," and "holographic paradigms," among other things. All of these notions are ingenious, and some of them may even be "true," if the word can be said to mean anything in this context; but for the most part, they are disembodied, value-free, and content-neutral. David Bohm's (1980) concept of the "implicate order" is purely formal; it deals with boundary relations, in which reality is viewed as a process that Bohm calls "enfolding" and "unfolding," or "holomovement." Similarly, Rupert Sheldrake's (1981) notion of formative causation by means of "morphogenetic fields"—a brilliant hypothesis if ever there was one—is also purely formal, as the name itself implies. It is not grounded in any concrete or sensuous reality, and it is certainly capable of being bent to any situation. It has been used thus far only in a positive sense, for example, to explain the growth of the antinuclear movement in politics, successful evolutionary adaptation in biology, or the process of learning in general. Yet the same theory can be used to explain contagion, or the rise of Fascism—*La Peste,* by Camus, is a perfect description of a morphogenetic field—or the spread of nuclear weapons, or addiction. As with classical mechanism, the theory is not able to discriminate in terms of content. The whole world dissolves in form. Here, as in the case of Bohm's work and that of so many other "process" thinkers, human beings somehow disappear from the picture. The whole thing becomes cosmic, a vast mental process divorced from specific

physical situations. Alfred Korzybski's famous dictum, "The map is not the territory," is not without relevance here.[15]

One of the most prominent thinkers in this category—and his work is explicitly cybernetic in nature—is Douglas Hofstadter, whose book *Gödel, Escher, Bach* appeared in 1979. Hofstadter's work illustrates the general point I am making here. The book is not easy reading, for most of the text deals with the nature of mathematical paradox of the sort formulated by Zeno of Elea in the fifth century B.C. Despite its density, the book has been lionized, selling hundreds of thousands of copies and winning Hofstadter the Pulitzer Prize and a spot as a regular columnist for *Scientific American.* As I plowed my way through it, I began to have an uncomfortable feeling: The book had no real content. It was all about puzzles and tautologies, designed to show that everything in our world, including the subjective concept of "I," was essentially symbolic patterned activity. Reality somehow disappeared from its pages. Everything was programming; the whole world had turned into artificial intelligence. I began to sense in Hofstadter a kind of computer jockey who got so fascinated by cybernetic operations that he decided they could and should be extended to the entire world.

There is a scene in the film *War Games* in which the young whiz kid—who has accidentally tripped into the Pentagon terminal and is busy simulating nuclear war on his home computer, causing the Joint Chiefs of Staff to actually prepare to bomb Russia—asks his machine, "Is this a game, or is it real?" His computer replies, "What's the difference?" As John Searle (1982) pointed out in a review of Hofstadter's second book (coauthored with Daniel Dennett), *The Mind's I* (1981), this simple point has been lost on Hofstadter. You can, says Searle, get a computer to print out the words "I am thirsty"; but no one in his right mind would attempt to pour a glass of water into the machine as a result. Plainly put, Hofstadter's brand of holism is completely out of touch with reality.

I subsequently had the opportunity to hear Hofstadter speak at an East Coast university where I was teaching. Significantly, the turnout was so great that the overflow had to be siphoned off into a room with a closed circuit TV. Hofstadter spoke for ninety minutes, and it was vintage stuff: what Achilles said to the tortoise and other Zenonian brain-twisters. As in *Gödel, Escher, Bach,* the talk was rich in form and devoid of content. That year I was teaching a course on the historical relations between holistic and mechanistic thought, and some of the students in that class came up to me after the talk and wanted to know what I thought. "Well," I said, "I'd be curious to know what Dr. Hofstadter thinks dreams are." To my surprise, one of my students elbowed his way through the crowd that surrounded Hofstadter, and came

back within ten minutes. "I asked him," he said, panting for breath. "Well? What was the reply?" "He told me that dreams were confused brain programs."

I won't repeat my reaction to this bit of cybernetic wisdom, but I ask you only to contemplate this: more than eighty years after Freud's *The Interpretation of Dreams,* nearly seventy years after Jung's *Psychology of the Unconscious,* and millennia after cultures such as the Greeks, the Egyptians, the Essenes, and aboriginal peoples from all over the planet recognized the value of dream symbolism for human life, a leading spokesman of the cybernetic age is telling his audience that dreams are "confused brain programs"! I wonder if the language of the body is also, for Hofstadter, a type of confused programming, and whether he finds animal and plant life disorganized and in need of cybernetic management. We really have to ponder what it means in the history of a civilization when a thinker of this sort can come to be regarded as a man of penetrating insight, a mind truly to be reckoned with.

The Reenchantment of Life

Let me conclude, finally, by saying that I am not categorically opposed to holistic thinking. Far from it. I wrote a whole book arguing that mechanism had no philosophical future, and I still believe that. My point is that the real issue, ultimately, is not mechanism versus holism, but whether any philosophical system contains an intrinsic ethic—and not a value-free one—and whether it is a truly embodied approach to the world. On these grounds, mechanism would seem to be disqualified, as Marcuse so effectively argued. But the holistic case is not so simple; there is holism and there is holism.

In *The Reenchantment of the World* (1981), I argued that what was on the philosophical agenda now was the revival of the magical tradition in a way that was scientifically credible. It is precisely this impulse that underlies the research of people such as David Bohm and Rupert Sheldrake, and from that point of view, their work is definitely worthy of our attention and respect. Such thinkers are quite literally the modern equivalents of Descartes and Newton; they recognize that the old paradigm is crumbling and they are out to construct a new one. What I am concerned about is that the magic will somehow get left behind in the process. By "magic" here I do not mean sticking pins in dolls; I mean the affective, concrete, and sensual experience of life. The paradigm I have in mind would be grounded in the real behavior of people in the environment. It would incorporate the sort of information

that arises from our dream life, our bodies, and our relationships to plants, animals, and natural cycles. And I am absolutely convinced that it would usher in a profoundly creative and liberated period in the history of the West.

Unfortunately, most holistic thinking today, and certainly that of the cybernetic variety, is moving in a very different direction. In the name of enlightenment, we are getting reification; we are drifting into a hall of mirrors. What is being lost, on all three of the levels I have discussed, is any sense of unmediated reality,[16] such as is celebrated in Japanese haiku, for example, or which comes to us through dreams, or through body awareness, or as a result of any extended experience with nature. Instead, what we are now moving toward is a world of pure metaphor, "programming," "patterned activity," what one writer has called "mysticism without a soul."[17] "Mysticism without flesh" might be more accurate.

Yet I do not believe this tendency is inevitable. On the philosophical and professional levels, at least, we might conceivably be able to exercise some epistemological restraint. Cybernetic thinking does not have to be, of necessity, disembodied and formulistic. In his book *The Gift,* Lewis Hyde (1979, 17–19), cites the example of a gift-giving ceremony among the Maori of New Zealand that reveals a cybernetic structure, but Hyde is well aware that the power of this structure is derived from its actual embodiment in a concrete situation: a history, a tradition, a gestalt that is felt to be alive by those who participate in it. Paul Ryan, American video artist and author of a book called *Cybernetics of the Sacred* (1974), once put it to me this way: God is Relationship. By "relationship" he did not mean a set of abstract relata, but a practice, a praxis, a living and embodied reality. There *are* no "circuits," there *are* no "feedback loops"; all that is fantasy. To think such things exist apart from real situations is a Neoplatonic dream; it is to fall into what Alfred North Whitehead called the "fallacy of misplaced concreteness." The French philosopher Maurice Merleau-Ponty recognized this tendency as early as 1960, and wrote the following in his essay "Eye and Mind":

Thinking "operationally" has become a sort of absolute artificialism, such as we see in the ideology of cybernetics, where human creations are derived from a natural information process, itself conceived on the model of human machines. If this kind of thinking were to extend its reign to man and history; if, *pretending to ignore what we know of them through our own situations,* it were to set out to construct man and history on the basis of a few abstract indices . . . then, since man really becomes the *manipulandum* he takes himself to be, we enter into a cultural regimen where there is neither truth nor falsity concerning man

and history, into a sleep, or a nightmare, from which there is no awakening.

> Scientific thinking . . . must return to . . . the soil of the sensible and opened world such as it is in our life and for our body—not that possible body which we may legitimately think of as an information machine *but that actual body I call mine,* this sentinel standing quietly at the command of my words and of my acts. (1964, 160–61; italics added)

We are at a crossroads now, and it is a crucial one, for this is the heart of the mythological shift I have been discussing. In our eagerness to reject the mechanistic science of the last three hundred years, we need to be wary of what we are replacing it with. The thing to ask of any new philosophical statement, any extension of computer hardware into schools, universities, or therapists' offices, and of any new toys such as Pac-Man or Apple II, is only this: does it take me into the things I fear most and wish to avoid, or does it make it easy for me to hide, to run away from them? Does it enable me to shut out the environment, ignore politics, remain unaware of my dream life, my sexuality, and my relations with other people, or does it shove these into my face and teach me how to live with them and through them? If the answer is the latter, then I suggest to you that we are on the right track. If the former, then it is my guess, as Merleau-Ponty says, that we are sinking into a sleep from which, in the name of enlightenment itself, there will be no easy awakening.

Notes

1. This essay first appeared in *Universities in Crisis: The Future of a Mediaeval Institution in the 21st Century,* ed. W. A. W. Neilson and C. M. Gaffield (Montreal: Institute for Research on Public Policy, 1985), and subsequently in *Journal of Humanistic Psychology* 26, no. 2 (Spring 1986): 24–51. It should be noted that Heidegger made strict distinctions between the categories of Being, technology, and scientific truth, and it might be argued that Roszak and others tended to confuse them. However, it was one of Heidegger's students, Herbert Marcuse (discussed later), who was able to show that although these categories might be philosophically distinguishable, they were not really separable; and that in actual practice, they easily got scrambled. Thus Marcuse argued, for example, that scientific truth as it developed in the seventeenth century actually had a technological a priori or hidden technological agenda; and that, by the twentieth century, this had largely come to define Being in Western industrial societies.

The later notebooks of Wittgenstein reveal his perplexity with the "grammar of theology" versus the logic of science, and the impossibility of establishing the epistemological superiority of the latter. For a general overview of the Frankfurt School, see Jay (1973). As for the "externalist" school in the history of science, there is a large literature in this genre, but the classic studies probably remain those of Merton and Zilsel, done in the 1930s and 1940s. See also the essays in Kearney (1964).

2. For a more extended discussion of this, see chapter 3 of Berman (1981). Descriptions of magical practice can be found in various works by the early twentieth-century British occultist Dion Fortune (Violet Firth). A more recent text is by Conway (1972).

3. On Soviet and American research into the paranormal, see Rossman (1979, 167–260) and McRae (1984).

4. I have tended in this article to blur the distinction between the concepts "value-free" and "disembodied." (Marcuse, it seems to me, does this as well.) Strictly speaking, they are not the same thing. Bateson's later work was certainly disembodied, but it was never value-free. His concept of "circuitry," for example, or of "Mind" (capital M), both of which he took from cybernetic theory, essentially added up to what in certain Eastern traditions is called "karma," a kind of nonlinear law of cause and effect. On this reasoning, the universe is not value-free but, rather, is suffused with a pattern that is self-defining or reflexive. Meaning is thus built into the system. In actual practice, however, a disembodied system can easily take on a purely formal character and fall into the "value-free" camp, and I discuss the susceptibility of Bateson's work (and of holistic/cybernetic thinking in general) to this tendency in chapter 9 of *The Reenchantment of the World*. Another way to see this distinction is to examine the difference between the magical tradition and Aristotelianism. Formally, a *telos* is definitely present in the Aristotelian world view, and meaning—e.g., the concept of natural place and motion—is embedded in the universe. Natural place and motion are, furthermore, very much a part of the occult tradition, and fall into the category of "sympathy," the theory that "like knows like," a notion that was present in Orphic and Greek shamanic traditions and in the writings of some of the pre-Socratics. Aristotle, in fact, may in some way represent the intellectualizing of this tradition, following the pattern of Plato's "inversion" of occult sources (on this, see Dodds, 1951). The problem is that once the living tradition gets disembodied, the system is still technically endowed with meaning or value, but only in an abstract sense. In actual practice, the purely formal aspect comes to the fore, and Marcuse wrestles with this in *One-Dimensional Man* (1966, 137–39, 147), saying that it is a precursor or anticipation of seventeenth-century science.

This same tension lies at the heart of the problem with Bateson's legacy. To put it succinctly, the early Bateson was an alchemist, the later Bateson an Aristotelian. All of his work as I have noted, was "value-laden," but the disembodied character of the later work turned it into a kind of cybernetic catechism and thus, in actual practice, it would seem to be as instrumentalist as the mechanism of the seventeenth century.

5. Ken Wilber is the author of several works, including *The Spectrum of Consciousness* (1977), *Up from Eden* (1983), and *The Atman Project* (1980). Wilber is, however, critical of certain aspects of "new paradigm" thought (see Wilber, 1982, 157–86, 249–94).

6. "Addicted to Video Games? It's Vidanon to the Rescue," *Victoria Times-Colonist* (British Columbia), October 8, 1983; from an article in the *Los Angeles Times.*

7. This figure was given by Edward Lias of Sperry Univac Corporation at a conference called "Future Mind," University of South Florida, April 14–16, 1983.

8. For an update of the debate, see *Chronicle of Higher Education* 27 (January 11, 1984): 7, 12.

9. For a holistic paradigm that I believe differs from the models being criticized in this article, see Maturana and Varela (1980). Varela's statement was made at a conference in Alpbach, Austria, September 7–11, 1983, entitled, "Andere Wirklichkeiten" ("Other Realities").

10 "Cybernetic ecology" is discussed by Carolyn Merchant (1980, 103, 238–39, 252, 291). For the Club of Rome report, see Meadows et al. (1974).

11. For a good example of a biology textbook in the cybernetic genre, see Gatlin (1972).

12. For some interesting examples, see the *Oxford English Dictionary* under the entry for "clock." Miners began to describe the direction of veins of ore as "lying at 9 (or whatever) o'clock"; Fenner (1650) says you must wind up your conscience every day "as a man does his clock."

13. On this and the following, see Bandler and Grinder (1975, 18–19, 158). For an example of a *body* therapy reduced to cybernetic terms, see Rywerwant (1983). I am grateful to Brian Lynn for pointing out these works to me and for the helpful discussions we had on current trends in New Age "therapy."

14. "True magic works," writes Father Sylvan, "through the phenomenon of resonance. One must know the exact words to say and one must say them in exactly the right place and the right time" (Needleman, 1982, 87).

15. Sheldrake (1981); Bohm (1980); see also Weber (1982). For an example of morphogenetic fields applied to the political (antinuclear) sphere, see Keyes (1982). Korzybski's statement was first given in *Science and Sanity,* published in 1933, and is repeated in the works of many other writers, including Gregory Bateson.

16. Strictly speaking, this is not true on the level of Pac-Man. Addictions do provide unmediated experience due to their absorbing intensity. The problem, of course, is that the world in which the addict is absorbed is unreal, and thus the pattern is one that might be termed "pseudoholistic." Bateson discusses this in his essay "The Cybernetics of 'Self': A Theory of Alcoholism" (in Bateson, 1972).

17. Needleman (1982, 140). Compare Murray Bookchin's comments on the entire issue (1983). Not all criticism of artificial intelligence, I am happy to report, comes from traditional "humanistic" quarters. Joseph Weizenbaum (1983, 58–62), one of the pioneers of artificial intelligence, has had some serious reservations about the field and its alienating tendencies. He discussed this in his review of *The Fifth Generation,* by Edward Feigenbaum and Pamela McCorduck, who argued that artificial intelligence is indispensable to all spheres of life. In this review, Weizenbaum writes, "The knowledge that appears to be least well understood by Edward Feigenbaum and Pamela McCorduck is that of the differences between information, knowledge, and wisdom, between calculating, reasoning, and thinking, and finally of the differences be-

tween a society centered on human beings and one centered on machines."

References

Bandler, R., and Grinder, J. *The Structure of Magic, Part I.* Palo Alto, Calif.: Science and Behavior Books, 1975.

Bateson, G. *Steps to an Ecology of Mind.* New York: Ballantine, 1972.

———. *Mind and Nature: A Necessary Unity.* New York: Dutton, 1979.

———. "Men Are Grass: Metaphor and the World of Mental Process." Rochester, Vt.: Lindisfarne Press, 1980.

Bentov, I. *Stalking the Wild Pendulum.* New York: Dutton, 1977.

Berman, M. *The Reenchantment of the World.* Ithica, N.Y.: Cornell University Press, 1981.

Bohm, D. *Wholeness and the Implicate Order.* London: Routledge & Kegan Paul, 1980.

Bookchin, M. "Sociobiology or Social Ecology, Part II." *Harbinger* 1, no. 2 (1983): 28–38.

Capra, F. *The Tao of Physics.* Boulder, Col.: Shambhala, 1975.

Chronicle of Higher Education. "Historian Calls for 'New Moral Indictment' of Slavery." 27 (January 11, 1984): 7, 12.

Conway, D. *Ritual Magic.* New York: Dutton, 1972.

Dodds, E. R. *The Greeks and the Irrational.* Berkeley: University of California Press, 1951.

Fenner, W. *Christ's Alarm.* 1650.

Ferguson, M. *The Aquarian Conspiracy.* Los Angeles: Tarcher, 1980.

Fogel, R. W., and Engerman, S. L. *Time on the Cross.* Boston: Little, Brown, 1974.

Gatlin, L. (1972). *Information Theory and the Living System.* New York: Columbia University Press, 1972.

Ginzburg, C. *The Cheese and the Worms.* Baltimore: Johns Hopkins University Press, 1980.

———. *The Night Battles.* Baltimore: Johns Hopkins University Press, 1983.

Heidegger, M. *The Question Concerning Technology, and Other Essays.* New York: Garland, 1977.

Hofstadter, D. *Gödel, Escher, Bach.* New York: Basic Books, 1979.

———, and Dennett, D. C. *The Mind's I.* New York: Basic Books, 1981.

Huggins, N. I. Article in *Commonweal* 100 (August 23, 1974): 459.

Husserl, E. (1970). *The Crisis of European Sciences and Transcendental Phenomenology.* Evanston, Ill.: Northwestern University Press, 1970.

Hyde, L. *The Gift.* New York: Vintage Books, 1979.

Jay, M. *The Dialectical Imagination.* Boston: Little, Brown, 1973.

Kearney, H. F., ed. *Origins of the Scientific Revolution.* London: Longmans, Green, 1964.

Keyes, K., Jr. *The Hundredth Monkey.* Coos Bay, Oreg.: Vision Books, 1982.

McRae, R. M. *Mind Wars: The True Story of Government Research into the Military Potential of Psychic Weapons.* New York: St. Martin's, 1984.

Maltz, M. *Psycho-Cybernetics.* New York: Pocket Books, 1969.

Mannheim, K. *Ideology and Utopia.* New York: Harcourt Brace & World, 1936. Reprint.

Marcuse, H. *One-Dimensional Man.* Boston: Beacon Press, 1966.

Maturana, H., and Varela, F. *Autopeisis and Cognition.* Dordrecht, Holland: D. Reidel, 1980.

Meadows, D. H., et. al., eds. *Limits to Growth.* New York: Universe Books, 1974.

Merchant, C. *The Death of Nature.* New York: Harper & Row, 1980.

Merleau-Ponty, M. "Eye and Mind." In J. M. Edie, ed. *The Primacy of Perception,* 160–61. Evanston, Ill.: Northwestern University Press, 1964.

Needleman, J. *Lost Christianity.* New York: Bantam, 1982.

Nichols, R. E. *The Science of Mental Cybernetics.* New York: Warner Books, 1971.

Rifkin, J. *Algeny.* New York: Viking, 1983.

Rossman, M. *New Age Blues.* New York: Dutton, 1979.

Roszak, T. *The Making of a Counter Culture.* Garden City, N.Y.: Doubleday, 1969.

Ryan, P. *Cybernetics of the Sacred.* Garden City, N.Y.: Doubleday, 1974.

Rywerwant, Y. *The Feldenkrais Method: Teaching by Handling.* New York: Harper & Row, 1983.

San Francisco Chronicle. "Computer Harm to Children." December 26, 1983.

Searle, J. R. "The Myth of the Computer." *New York Review of Books* 29 (April 29, 1982): 3–6.

Sheldrake, R. *A New Science of Life.* Los Angeles: Tarcher, 1981.

Weber, R. (1982). "The Enfolding-Unfolding Universe: A Conversation with David Bohm." In K. Wilber, ed., *The Holographic Paradigm,* 44–104. Boulder, Col., Shambhala, 1982.

Weizenbaum, J. Review in *New York Review of Books* 30 (October 27, 1983): 58–62.

Wilber, K. *The Spectrum of Consciousness.* Wheaton, Ill., Theosophical Publishing House, 1977.

———. *The Atman Project.* Wheaton, Ill., Theosophical Publishing House, 1980.

———. *The Holographic Paradigm.* Boulder, Col.: Shambhala, 1982.

———. *Up from Eden.* Boulder, Col.: Shambhala, 1983.

Zukav, G. *The Dancing Wu Li Masters.* New York: William Morrow, 1979.

DATE DUE

11/23/16			